SECRET
REDDITCH

Anne Bradford

Photography by John Bradford

AMBERLEY

First published 2021

Amberley Publishing
The Hill, Stroud
Gloucestershire, GL5 4EP

www.amberley-books.com

Copyright © Anne Bradford, 2021

The right of Anne Bradford to be identified as the
Author of this work has been asserted in accordance
with the Copyrights, Designs and Patents Act 1988.

ISBN 978 1 4456 8147 4 (print)
ISBN 978 1 4456 8148 1 (ebook)

British Library Cataloguing in Publication Data.
A catalogue record for this book is available from the
British Library.

Typesetting by Aura Technology and Software
Services, India. Printed in Great Britain.

Contents

Introduction

A Mystery Solved

For many years people have been wondering exactly when and where Redditch began. We know that in the 1200s a Latin document mentioned *de Rubeo Fossata,* 'the Red Ditch'. The water was probably stained red either from iron ore or red clay. Then in 1247, the Normans referred to a place known either as *la Rededich* or *le Rededych* according to whether the relevant scribe thought it was male or female.

However, retired headmaster Ralph Richardson was studying the Domesday Book of around 1086 when he realised that Redditch was founded in the Tardebigge area. He writes:

> Tardebigge is not a town but an area, similar to a parish. It was once much larger than it is today and almost reached Warwickshire. Consequently all the land which is now Bordesley

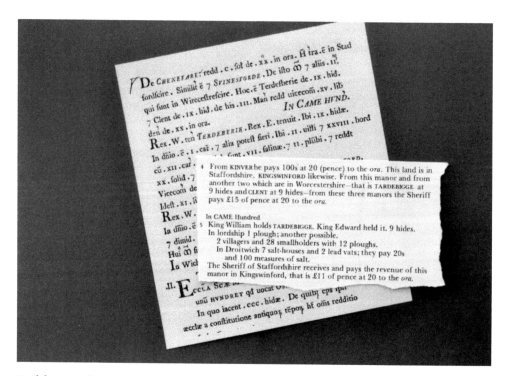

Tardebigge in the Domesday Book with a modern translation.

Abbey meadows was once in Tardebigge. There was a vil (a cluster of houses) where Redditch now stands. Therefore, the early history of Redditch is part of the history of Tardebigge. In the late 900s, the land was owned by King Ethelred the Unready, but it was bought by the Dean of Worcester for his church in the 12th century and given to Bordesley Abbey.

The Romans Were Here!

The Roman occupation of Britain began in AD 43 and lasted for 300 years. They built a 6,000-mile network of roads during the first forty years, mainly to facilitate the rapid movement of troops. The roads usually went the shortest distance between

Icknield Street Drive.

Icknield Street, a footpath between Papermill Drive and the Coventry Highway.

two points, ignoring hills and valleys. Icknield Street reaches Redditch at Washford, and continues along Icknield Street Drive to the Coventry Highway (A4023). From there, it becomes a footpath through a residential part of Church Hill. Then it goes along Tanhouse Lane and Icknield Street to Dagnell End Road (B4101) and onwards to Birmingham.

There are more impressive, grander Roman structures in Britain but none match the sheer ambition and achievement of the military engineers who constructed the network of roads linking all parts of Britain during the early years of the conquest.

Icknield Street, north of Redditch, on its way to Birmingham.

1. Hunt End – A Redditch Village Full of Surprises

The Knights Templar

Chapel House Farm in Hunt End overlooks what was once one of the largest moated sites in Worcestershire, created by the Knights Templar. They were an order of warrior monks established in the early twelfth century to protect pilgrims travelling to the Holy Land.

The moated site is approximately 130 metres by 200 metres. The moat only partially exists today but a section filled with water is clearly visible from the road. In the centre of the island stands the Moat House, a seventeenth-century Grade II listed building. Some parts may be earlier. By the sixteenth century the site was called Chapel House Farm. The 'chapel', however, gradually deteriorated and by 1986 was little more than a ruin. It has since been rescued and sympathetically restored.

An old map showing the site, together with details from a former will, suggests that a typical Elizabethan brick house with cross wings at each end existed at that time.

At some point that house was demolished and replaced by various buildings until it became the present large farmhouse that you see today.

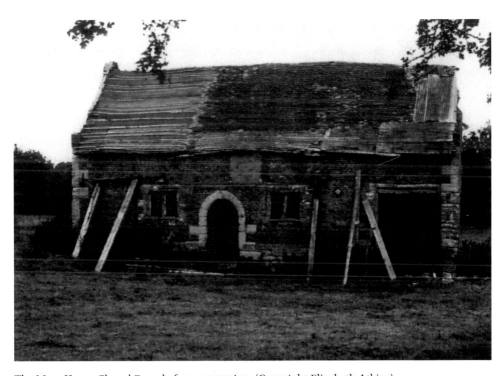

The Moat House Chapel Farm before restoration. (Copyright Elizabeth Atkins)

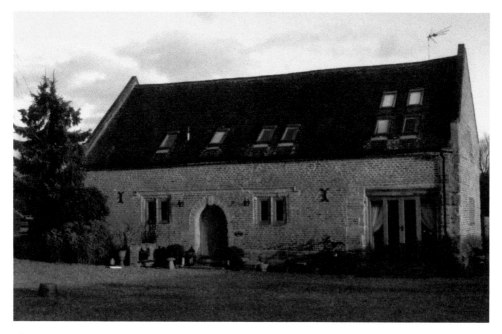

The Moat House Chapel Farm after restoration.

The Perry Mill

A perry mill, surrounded by pear orchards, stood until 1988 at Hunt End beside the Feckenham Road. Built sometime between 1790 and 1810, the building was in a poor state. It was offered to Avoncroft Museum of Historic Buildings, who carefully demolished, rebuilt and restored it at the museum. A donkey or a small horse in a yoke pushed an upright stone wheel round a channel in the millstone to produce the pulp from pears,

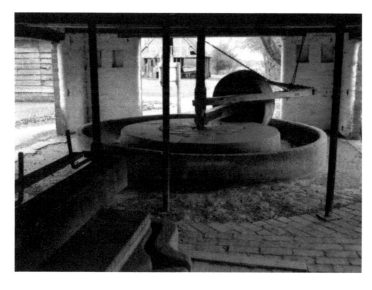

The Perry Mill from Hunt End, restored and now in Avoncroft Museum.

which was pressed to extract the juice. This was then fermented to make perry. The museum has its own orchard and periodically demonstrates this milling process to the public.

The Victorian Post Box

Queen Victoria reigned from 1837 to 1901. The postbox in Hunt End with V. R. and a crown dates from that period. Wlliam Avery, writing in the late nineteenth century, notes:

> The early postal arrangements of the town were exceedingly simple and unassuming. Once a week a foot messenger came from Henley into the town with a horn, which he blew to give notice of his arrival. He would then distribute letters and receive others 'if any'. He would then go on his way and send them off at his convenience.

In 1840 Roland Hill introduced a new system. The sender would pay for delivery by purchasing an adhesive stamp to be stuck on the envelope. This guaranteed delivery to any part of Britain for one penny. People took their letters to the post office until the 1850s when letter boxes offered greater convenience.

Mail coaches were efficient but expensive. Mail was often delivered on the same day that it was posted, and large towns might have up to six deliveries a day.

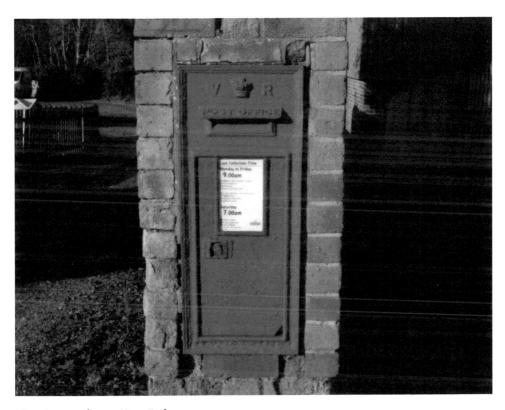

Victorian post box at Hunt End.

2. Bordesley Abbey, Redditch

The First Excavations

One sunny afternoon in June 1863, a group of unlikely companions, some carrying buckets and spades as though heading for the beach, set out to walk the short distance between Redditch and the Bordesley Abbey meadows. Robert Bartleet, one of the most important men in Worcestershire, led the procession. He was Justice of the Peace, Deputy Lieutenant for the County and Captain in Command of the 17th Worcestershire Rifle Volunteers. He also owned one of the world's largest needle factories, William Bartleet & Sons, on Prospect Hill. From the windows of his office he could see the mounds and depressions of the Bordesley meadows and he was full of curiosity to know what lay beneath the soil.

With him was his wife, who was carrying a well-stocked picnic basket, and their three eldest children. Bringing up the rear was the local vicar and James Woodward, who

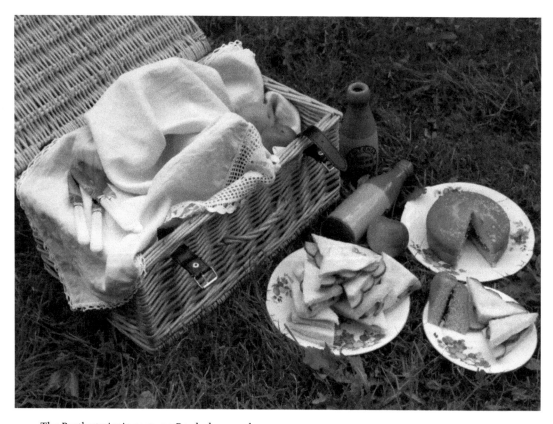

The Bartleet picnic party on Bordesley meadows.

was employed supposedly as tutor to the Bartleet children but was there more for his knowledge of archaeology. The children dug earnestly in the soil, Mrs Bartleet dispensed cucumber sandwiches and the vicar nodded off.

Robert Bartleet and James Woodward, armed with pencil, notebook and a borrowed Rifle Corps cord, measured and drew diagrams of the mounds and hollows. Woodward knew that most Cistercian monasteries were built to the same design. He only had to look at one Cistercian map to identify the bumps and hollows at Bordesley.

They found plenty of hand-made tiles, most of which were broken. Those intact were later taken to St Stephens Church for safe keeping where they can now be seen on request.

A New Abbey

On Tuesday 22 November 1138, twelve monks arrived to start building a new abbey. The site was on the edge of Feckenham Forest. There was so much fallen wood around that the area was renamed Bordesley because of all the wooden boards.

The ground was wet but the Cistercians were excellent civil engineers. They began by changing the course of the River Arrow. At the bottom of the slope, where the traffic island and the supermarkets are now, they created a huge lake as large as two football pitches to help drain the site.

The monk's fish ponds at Bordesley Abbey.

These were Cistercians monks who led a dedicated life of silent prayer, meditation, and spiritual readings. They also believed that hard manual labour purified the soul. They spoke rarely and ate only one meal a day – with no meat.

There were seven services a day. The first one, Prim, was at two o'clock every morning! Carrying candles, the monks stumbled down the night stairs. You can still see a few of the stairs in the Bordesley Abbey ruins.

They gathered in the chapter house to hear the Cistercian commandments. If any monk felt that he had transgressed one of these rules, he would stand up and throw his hood back to show his identity. The abbot would ask 'What sayest thou?' and the monk had to call out 'Mea culpa'. The abbot would question him about his sin and give him penance. Sometimes, if a monk failed to confess a sin then his 'friends' would 'twit' on him. The accused monk would have to say a prayer for those who accused him.

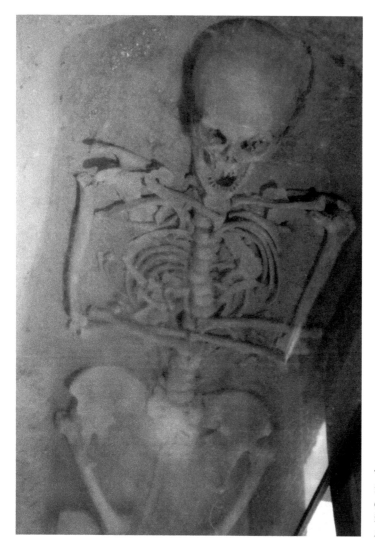

The skeleton of a monk from the Bordesley excavations, now in the Bordesley Abbey museum.

At its height the abbey had thirty-four monks and seventeen lay brothers (assistants). It became the fifth richest abbey in England and owned around twenty farms as well as large stretches of land between Redditch and Wales. Its wealth came from the sale of wool; their sheep produced the softest wool in in the world.

A museum stands next to Bordesley meadows, describing the lives of the monks. Here are skeletons of the monks taken from the meadows. The abbey was a cold, damp place and the bones show that the monks suffered from arthritis and rheumatism.

Who Built the Abbey?

Bordesley Abbey was built in 1138. This was only a few years after Henry I died. He loved children, which was fortunate as he had twenty illegitimate offspring. He also had two legitimate children, his daughter, Matilda, who was born in 1102, and a son, William, born the following year. Prince William was expected to inherit the throne but, tragically, he was drowned when he was in his late teens.

King Henry was very keen on education and installed a school near the throne room. Three of his pupils were involved in the building of Bordesley Abbey. The first was, of course, his daughter, Matilda, but also at the school were twin brothers Waleran and Robert de Beaumont, who were two years younger than Matilda. When the boys were

Villages were burned to the ground and crops destroyed.

fourteen, their father died and their mother remarried. As they were related to the king, he took them under his wing. Both boys were brilliant mathematicians – Waleran was looking after the extensive family finances when he was only twelve. The younger twin, Robert, was disabled but he helped to raise funds for a new abbey being built at Garenden in Leicestershire.

As for Matilda, when she was only around eight years old, she was betrothed to one of the most important men in Europe, the German-based Holy Roman Emperor. He was twenty years older than Matilda but the king felt that this would be compensated for by the fact that any male child of theirs would be king of Germany, France and England. Unfortunately, the emperor died in 1125, leaving Matilda (now an empress) childless.

Henry I insisted that Empress Matilda married again and even found her a husband, a handsome red-haired count. Matilda was not pleased as she was now twenty-six years old and the count was only fifteen. Also she was now an empress and he was a mere count. However, the marriage took place and, happily, it resulted in three male children.

Henry summoned his barons and made them swear an oath of allegiance to Matilda after his death. The empress was the rightful queen but the trouble was, first, that she was female, and, secondly, she lacked genuine support. She was said to be 'puff'd up with intolerable pride'.

Then the late king's nephew, Stephen, seized the crown and proclaimed himself king. Some barons supported him, others supported Matilda. So began nineteen years of civil war. A monk wrote in the Anglo-Saxon Chronicle:

> They levied taxes on the villages every so often, and called it 'protection money'. When the wretched people had no more to give, they robbed and burned the villages so that you could easily go a whole day's journey and never find anyone occupying a village nor land tilled.

Empress Matilda proved to be an ambitious and resourceful woman. She was captured and imprisoned twice during the civil war and twice she escaped, once pretending to be a corpse in a coffin being taken for burial, and on another occasion dressed in a white fur coat during a snowstorm.

3. The Building of Bordesley Abbey

The Empress and War

A foundation charter exists stating that Empress Matilda founded the abbey in 1135. There's no doubt that she was raising funds, and she was then given both money and items such as churches and mills. However, there is a second foundation charter saying that the abbey was built by Waleran de Beaumont in 1138 with no mention of Matilda. This was probably because she had to return to her home in France, her property was being invaded, and she had had three little boys in rapid succession, in 1133, 1134 and 1136. She was dangerously ill for six months after the birth of her second son. Consequently, the building of the monastery was in Waleran's hands. He inherited a financial problem: many workers such as carpenters and bricklayers had worked on the monastery for some months and now they wanted to be paid.

Waleran organised the biggest event ever seen in the midlands. Earls, barons, knights, ladies, abbots, friars and monks were invited to the site. The priests staged elaborate ceremonies to expel the devils. Money flowed; for example, in return for a pile of silver, visitors were promised burial in the abbey grounds after their death.

Waleran claimed to be the founder of the abbey in 1138. He was made 1st Earl of Worcester, and his cunning PR stunt has been remembered rather than Matilda's prayerful foundation.

A medieval illustration of Waleran on horseback.

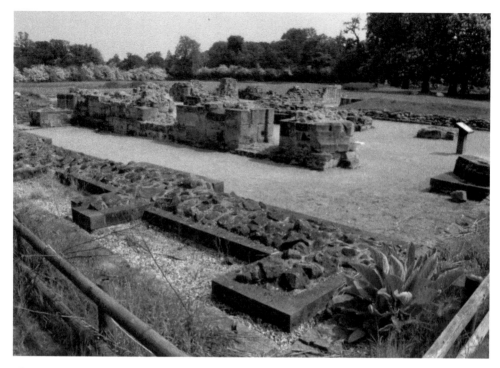

The ruins of Bordesley Abbey reveal its archaeology.

The Nightmare

In 1348 the Black Death arrived. Large black pustules or blotches appeared under the arms, in the groin or any place where there were lymph nodes. The fingers and toes curled inwards and turned black. More than half of the victims died and death usually

The Black Death arrived in England in 1348.

came within a week. By the time the epidemic had come to an end, four abbots had died, and there were only fourteen monks and one lay brother left to run the abbey. It fell into disrepair; for example, the irrigation system was neglected, the floor sank and had to be rebuilt four times.

The Last of the Abbey

In May 1538, the abbot of Bordesley, John Day, heard a rumour that Henry VIII had his eye on the abbey. He immediately began to sell or donate anything that was of value. The medieval processional cross went to Our Lady of Mount Carmel in Redditch. The three bells of Bordesley were taken by St John the Baptist Church at Strensham, and two embroidered priests' robes he gave to Downside Abbey in Gloucestershire. Even the hay was cut early and sold.

John Day surrendered the abbey on 17 July. The townsfolk raided the abbey and removed anything that could be taken in a cart.

Redditch Council Buys Bordesley Meadows

The Redditch Bordesley Society was founded in 1952 to try to raise enough money for excavation of the abbey fields. By 1960, after eight years of hard work, they had raised enough to employ archaeologist Kate Hughes, but not enough for a full-scale dig.

Then young Walter Stranz saved the day. Through his innocence, he managed to achieve in ten minutes what the Bordesley Society had been trying to achieve for ten years. He became a councillor and, because no one else would take the job, he was voted in as vice chairman of the Finance Committee. One holiday weekend in 1958 or 1959, most of the councillors were on holiday including the chief finance officer, when Walter was called in to see the town clerk. He wanted Walter to authorise the purchase of the Bordesley Abbey meadows for £5,000. He said that they had just come on the market and everybody would be after them. It was a great bargain, a once in a lifetime opportunity. They needed purchasing immediately. There was no financial risk because the meadows could be sold for housing, which would make the council rich. So Walter signed all the appropriate documents. It turned out there were no more bidders, there was no rush and the council had no intention of using them for housing. In addition, the site had been bought in three stages so the total cost was a great deal more than £5,000. Forge Mill was included in the sale. It later became the museum.

Walter has a final word: 'The strange thing is that the Forge Mill and Abbey sites total 104 acres and the Council only purchased 80 so somewhere there are fourteen acres that don't belong to the Council.'

4. A Jousting Accident That Changed the Course of History

In 1535, Henry VIII was forty-four years of age, healthy and good tempered. Suddenly he changed. In 1538 he began closing the monasteries. He executed more people than any other monarch in English history. He even sent his respected adviser, Thomas Cromwell, to the scaffold (and afterwards regretted it). Could there be any explanation for this change of character?

It could have been because he suffered serious brain injuries in a jousting tournament. On 24 January 1536, he was wearing full armour when he was thrown from his horse, also in full armour, which fell on top of him. Some reports say that he was unconscious for two days.

How a Farm Became a Stately Home

Henry VIII had one good friend whom he had known all his life, Lord Windsor. For five centuries Lord Windsor's family had acted as Stewards of Windsor Castle, hence the family's name.

In late November 1542, Lord Windsor was living in Stanwell Manor, an old building but in a good state of repair. The house was stocked with Christmas provisions. Henry VIII asked to be invited to dinner at Stanwell and so Lord Windsor laid on a sumptuous meal. At the end of the meal Henry VIII told Lord Windsor that Stanwell Manor was to be exchanged for Bordesley Abbey. Lord Windsor was astonished and said that surely the king could not be serious, but the king told him to go and see his solicitors in the morning. There, Lord Windsor found that not only were all the documents for the exchange already drawn up but if he wanted to keep his head on his body he needed to leave immediately.

The story goes that late on a cold wet November afternoon, after a journey of more than 100 miles (170 km) Lord Windsor arrived at Bordesley Abbey to find it in ruins. He was told about an old grange that once belonged to the abbey at Hewell, around 2.5 miles (3.9 km) away.

This is how the Windsors became the lords of Redditch for the next 400 years. They also owned 12,000 acres in Worcester, 17,000 in Glamorganshire, and 12,000 in Shropshire.

Hewell Grange

Three miles north-east of the Redditch town centre, just off the Brockhill Road, is an area so secret that if you accidentally entered it you might find yourself behind bars. This is, of course, HMP Hewell Grange, now a prison.

The building has only been a prison since the end of the Second World War. For 400 years, from 1542 to 1947, it was the home of the Windsor family.

The house was rebuilt three times over the centuries by either the Plymouths or the Windsors – the two families had intermarried. All the houses suffered from the same problem: subsidence, due, perhaps, to being too near to the lake.

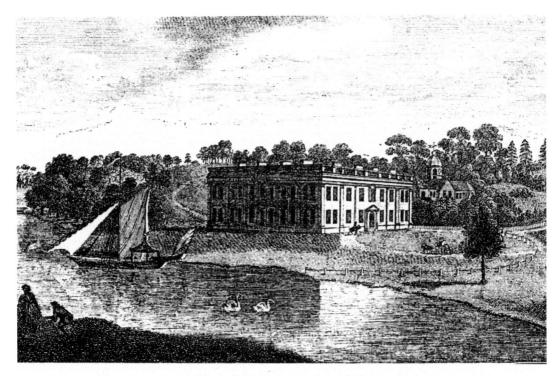

Hewell Grange in the 1700s

The first house at Hewell Grange in the 1700s.

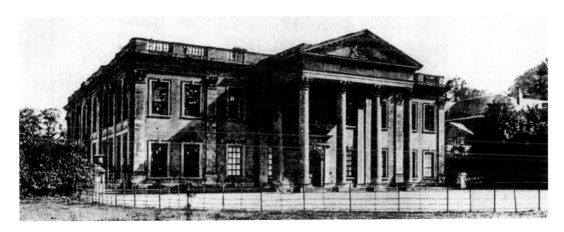

The second house at Hewell Grange.

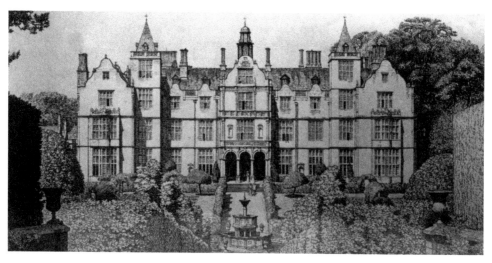

Hewell Grange. The third house was built in 1884–91.

Disaster at Tardebigge

In 1775 a disaster hit Tardebigge. The church collapsed. Among the debris was part of a life-sized memorial to Henry, Lord Windsor who died in 1605. The son of Henry had been shown kneeling at the head of the prostrate figure of his father. After the church

Part of the kneeling figure of Thomas, son of Henry, Lord Windsor, kneeling at his father's tomb.

collapsed, all that was left was a red coat and a gold buckle. It was stored with some other rubble under the stone stairs that went up to the belfry. There it remained for more than 250 years until it was spotted by a church member, Rhona Cash OBE, who insisted that it was removed, cleaned up and put on display.

A Village Hall Becomes a Pub

Very few people know that the original Tardebigge public house was built as a memorial for Clive of India. His real name was Thomas Hickman. The fifth earl had no children and so he adopted his sister's son, Thomas Hickman, who was born in 1725 in Shrewsbury. He was a disruptive teenager, and his relatives were only too happy to send him to India with the East India Company. However, he proved to be a first-class soldier, taking part in the many battles between the various factions in India until eventually he became governor. He always felt that the British had not given him the credit that he deserved in promoting their interests. Lady Harriet Windsor was a descendant and determined that people should know how courageous and successful he had been.

At the beginning of the 1900s, she owned a patch of grass near the entrance to the Grange. She built the most magnificent village hall in England. It was equipped with a library, sewing machines, cookers, workshops and a stage. It was given to the town by the Plymouth family in 1911 in memory of Clive of India.

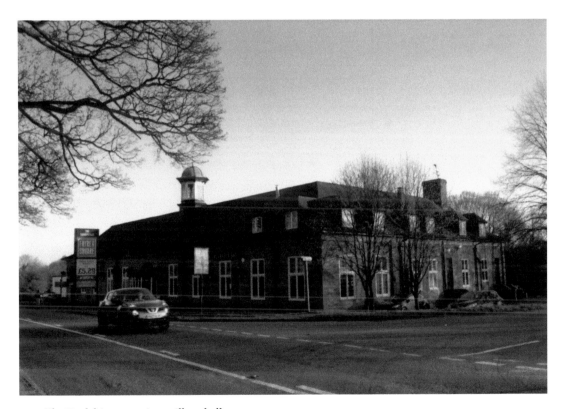

The Tardebigge, a unique village hall.

Unfortunately, the villagers were not able to enjoy their village hall for long. War broke out and the village hall was converted into a convalescent hospital.

In around 1945, the estates in Redditch were all sold but the agent made an error when it came to selling the village hall. It was only listed as a piece of land and consequently only sold for a few thousand pounds. The villagers tried to get it back but the person who had bought it wanted £8,000! A committee was set up to raise funds and although Lord Windsor donated £3,000, the villagers were unable to raise enough money.

The Famous Worcester, Birmingham and Tardebigge Locks

From Tardebigge church, an old path leads down to the Worcester and Birmingham canal and Tardebigge Tunnel. Here is the much-photographed new wharf, built in the nineteenth century. The canal is famous for having the longest line of locks in the UK, with thirty narrow locks (fifty-eight in all) on a 2.25-mile (3.6-km) stretch. The canal rises 220 feet (67 metres) to the Tardebigge Tunnel.

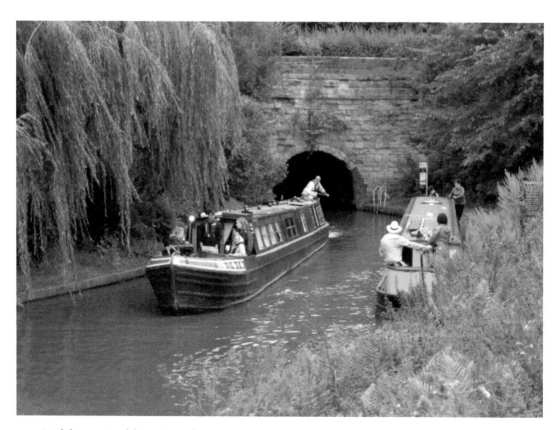

Rush hour in Tardebigge Tunnel.

5. Redditch the Needle Town

For over a hundred years, from around 1850 to 1960, Redditch was supplying needles right across the world. Millions and millions, every day – said to be 200 million a week from 1850!

Needles for sewing, for knitting, for crochet, for gramophones – hundreds of different types – not only to shops and factories, but also to hospitals (Redditch was the only place to make needles fine enough for eye surgery), to yachtsmen (only Redditch made needles strong enough to repair sails), and to space stations (Redditch made the needles to secure the tiles of NASA's space shuttle). Tucked away in Forge Mill museum is a copy of the oldest known needle. It's made from a plant. With it is a needle, used for sewing space age garments.

And not only needles. A fish hook is only a bent needle.

The oldest needle and a
space-age needle.

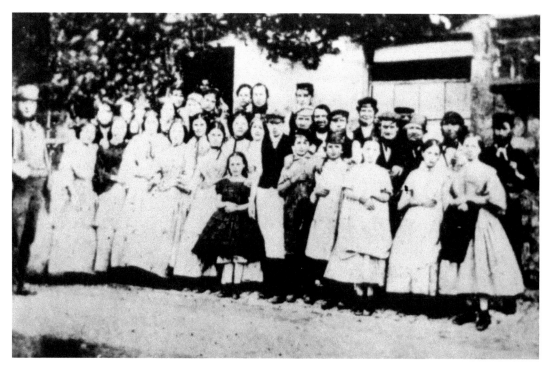

The entire village of Long Crendon about to set off to Redditch.

The Needle Makers

By the 1800s the countryside had become overpopulated and the pay of an agricultural labourer was barely a living wage. Needle making was much more lucrative; consequently needle makers flooded to Redditch from across England, from Wales in 1790, from Scotland in the 1800s, from Chester in 1808, and from a whole village, Long Crendon in Buckinghamshire, during the mid-1800s. They gathered to have their photograph taken before they left the village. If you have one of the following surnames your ancestors probably come from Long Crendon: Spires, Wharrad, Govier, Harris, Levy, Hims, Johnson, Laight, Lee, Lewis, Spencer, Tyler, Turner Mallam and Kirby-Beard.

A Cottage Industry

In the early days, needle making was often a cottage industry. Although there were around forty different processes you only needed a small furnace, a grindstone and an assortment of simple tools. The needles had to be washed and polished several times, known as 'scouring'. Consequently one great advantage of living in Redditch was the good supply of water from the River Arrow. Another reason Redditch was so popular was that there were several disused corn or iron mills that could easily be converted into scouring mills. Redditch museum, Forge Mill, is an old scouring mill.

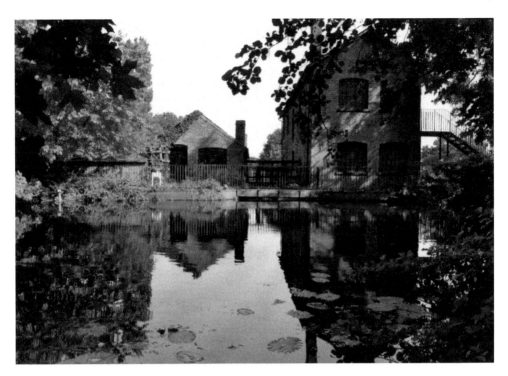

Forge Mill and the millpond.

The Shanty Town

If you look at the census returns you will see that the 1841 census shows there were 3,014 inhabitants in Redditch. During the next thirty years, the population more than doubled to 6,737. New arrivals had a nasty shock. There was very little accommodation

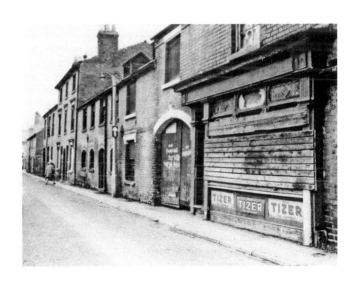

Old Walford Street, showing the dilapidated houses of the poor.

to rent and what was available was expensive. Houses were hastily built with leaking roofs, windows that didn't close, ill-fitting doors and only one chimney. Some were built round the outside of a quadrangle where people kept chickens and pigs. Water was from a communal pump in the yard or a well in the kitchen. Brick-built middens were provided for the rubbish but they were supposed to be isolated and some were leaning against the house! Toilets were few and far between, usually one lavatory to several houses. A country persons' idea of a low flush was a deep hole down the garden, covered with a wooden seat.

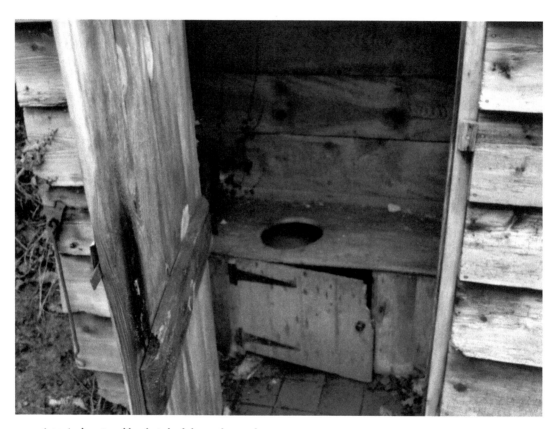

A typical seat and bucket shed down the garden.

6. Making a Needle

1. Stretching the Wire

The wire should be mild steel wire (around 8 per cent carbon). It needs to be stretched to the right thickness. Here is a sketch of a team of teenagers stretching the wire in around 1850 in Givry Works.

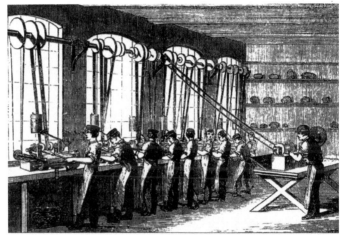

Stretching the wire in around 1800.

The Reducing Room, Givry Needle Works, Hunt End, Redditch, circa 1865.

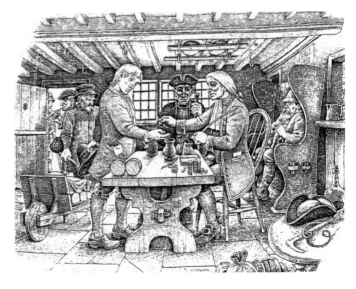

Drawing by Norman Neasom of a needle master paying the needle makers.

28

2. Straightening and Cutting the Wire

The wire is straightened and cut into the length of two needles with shears. Needles are worked in twos. Straightening the wire was considered to be a job for the ladies. In 1839, a young man, Joseph Turner, who lived in Ipsley Street, visited a wire works near Sheffield and noticed that the wire was being straightened by dipping in oil instead of water. He tried it out at home and found that it reduced the number of distorted needles. Many of the local needle manufacturers began using oil instead of water. The wrath of a crowd of 700 women fell on Joseph's head. They stood outside his house and tin-panned him, that is they banged kettles, saucepans, anything that would make a noise. They made his life a misery. The following year, a public meeting was held in the large Rifle Corps Room in Red Lion Street to sort things out. At the meeting it was said that 700 women in the town earned their living by straightening needles and if their work was removed, the only other employment available in the town was prostitution. Faced with the prospect of a town of 700 prostitutes, the needle masters gave way and signed a form to say that in future needles would only be hardened in water. A fund was started to buy up and destroy all the equipment using oil. One of the needle masters, Richard Hemming, warned that if all the rival manufacturers used oil to produce cheaper needles, then they would have to follow suit. Joseph Turner continued to use oil. An effigy was made of the needle maker who did Joseph's hardening and burned in public. Joseph moved to Stratford. Eventually, all the needle manufacturers used oil and it became standard procedure. Joseph Turner returned to live in Redditch.

There was no noticeable increase in the number of prostitutes.

3. The Pointers

The pointers were better paid than the other workers for two reasons. First, the work was dangerous. They pointed the needles by holding a handful of fifty or so against a rotating grindstone. Occasionally the grindstone shattered. There's a stone set in the north wall of Forge Mill with the initials EM 1816 carved in it. This is in memory of Edward Murray, a needle maker who was killed by an exploding grindstone. The stone itself is part of the wrecked grindstone. A model of a pointer at work in Forge Mill museum. Secondly, as the pointers worked they breathed in steel dust, causing pneumoconiosis of the lungs so they only expected to live until they were around thirty. For this reason they received high wages, which were soon spent as there was no need to save for their old age. The management found it difficult to recruit men whose work shortened their life expectancy so they treated the pointers with respect. The pointers were usually the ringleaders of any trouble.

Many efforts were made to improve the lives of the pointers but they enjoyed their high salary and refused to change. On 11 January 1822 an inventor came all the way from Sheffield with a great new invention: a muzzle of magnets to catch the steel dust as it came off the needles. The pointers were not at all grateful. They smashed the muzzle of magnets and struck the inventor. The story goes that they injured him so badly that he was left for dead but one of the pointer's wives managed to drag him to a safe place and nursed him back to health. They fell in love and the inventor wanted to marry her but she refused as she was only a factory girl and he was a gentleman. However, when he died he left her enough money to send her daughter to a private school.

A model of a pointer at work in Forge Mill museum.

The Pointers Go on Strike

It was almost unheard of for workers to go on strike. There was no unemployment benefit; if you had no job you had no income. Then the needle masters proposed to reduce the wages of the workers by sixpence (2.5p) a day, a lot of money in those days. The pointers were the only ones who could afford to go without salary for a few weeks. Every morning instead of going to work, they met in a lane, probably Green Lane, near Crabbs Cross. They had the support of the townsfolk and they were well supplied with ale, bread and cheese. However, after three weeks the weather changed and the food ran out so that the men on strike were wet, cold and starving. Fortunately, at that point the needle masters gave in and the strike was over.

A second strike occurred in 1830 when the needle masters proposed to deduct threepence (2.5p) a pack of needles.

A third strike came in 1846 when one of the Needlemasters hired a pointing machine. Of all the disturbances, this was the most serious. The machine was broken up and the pointers formed themselves into a union. It lasted for many months, and the needle makers were going hungry and falling behind with their rents. In the end, the needle masters got together and devised a list of payments to be made for each process. In November the pointers accepted the terms and went back to work.

4. Stamping and Eyeing

In around 1830 William Green, who lived in Astwood Bank, invented a process by which the eye of the needle could be drilled instead of being hammered. It was a great secret. No one could understand how he had managed to do this, and so one night one of the needle makers put a ladder against his window and watched him working. Then the secret was out and all the needle makers started drilling the eyes the same way.

In around 1820 the kick stamp arrived. Instead of being hit by a man with a hammer, the needles were punched by a drop hammer. You pressed a foot pedal and the hammer came down and punched the eye. There's one preserved in Forge Mill museum.

The kick stamp model in Forge Mill museum.

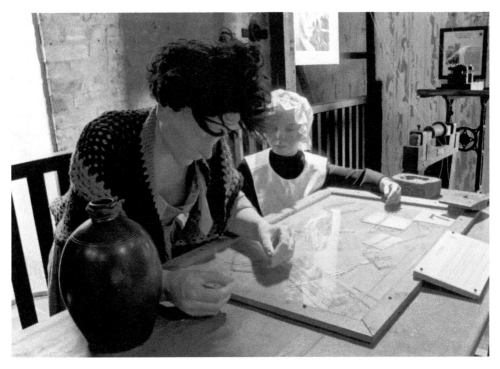

Mother and daughter 'spitting' at home.

5. Spitting

A young man moved house and came to live in Redditch. He decided to pay a call on a new neighbour. He knocked on her front door and her little girl answered. She said, 'Oh, you can't see my mother now, she's spitting'. He wondered what on earth she was doing. It was some weeks later that he discovered that the mother had been threading needles on to fine wires in order to clean them and this is known as 'spitting'.

The needles are still joined together in twos, end on. If you start to handle them you will find that they bend very easily. They need to be hardened.

6. Heating – Hardening and Tempering

Needles must be heated twice. The first time they need to reach 1,500 degrees. If you didn't have a temperature gauge you could assess the temperature by the colour of the metal. This is white hot heat. After cooling, the needles are brittle so they have to be 'tempered' (i.e. heated again to a straw colour).

They are now perfect except for one thing – they look terrible, dark in colour and rough in texture.

7. Scouring and Polishing

Once a job for granny. She would carefully place the needles between two layers of soap and her favourite abrasive, roll it up into a sausage-shaped bundle, tie it tightly and sit and rub the needles for several days until they shone. Over the centuries all kinds of

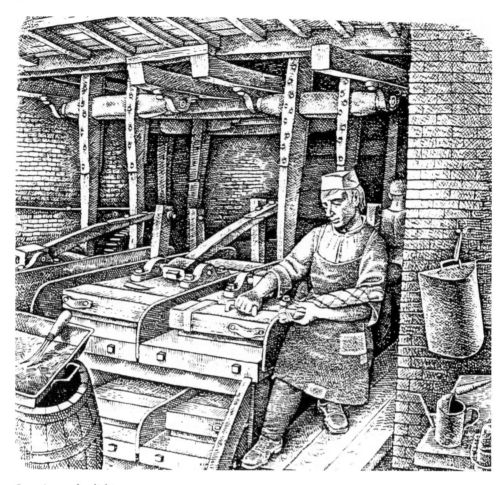

Scouring and polishing.

powdered material was used as an abrasive. In Walkwood Road (originally known as Warkwood Road) there's a cottage with a large front garden or yard. There's now nothing on it, but a horse mill used to be there for crushing stones or bones or anything else that could be reduced to a powder.

There were many scouring mills in Redditch. Philip Coventry lived next to one in Red Lion Street. He says:

> Next door was a scouring mill and the mill was going for ten hours a day every working day. There was no chance of having a lie-in, it was only three feet away and the top of the machinery was level with my bedroom window. At the back of the factory there were eight barrels each revolving on a central spinning drum. All day long it would be thud, thud, thud, trundle, trundle, trundle. You got used to the noise and after a while you didn't notice it.
>
> Mr Betteridge was the scourer. He had great big clumpy boots and an apron with a sack tied over it.

8. The Secret Parcels

At last the needles would be ready for despatch. If you were not sending by train or lorry, you made them into a nice parcel with your trade name on the cover and took it to British Mills. In the entrance hall of British Mills there was a mahogany table the length of the hall and behind it a row of young ladies ready to send your parcel anywhere in the world.

Before you handed the parcel over, you had to keep it covered and reveal the address only at the last minute. This was because, crowding round you, would be your competitors, anxious to see where you were sending your parcel so that they could steal your business.

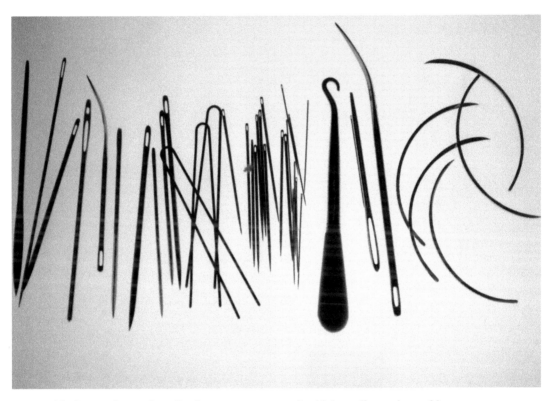

Redditch manufactured needles for every purpose and sold them all over the world.

7. Three Famous Manufacturers

Samuel Thomas of British Mills

Redditch was on the edge of the Black Country and at the forefront of the Industrial Revolution. In the mid-1800s, Samuel Thomas was a blacksmith in his early thirties, living in Bilston in the Black Country. Then he made a decision that changed the face

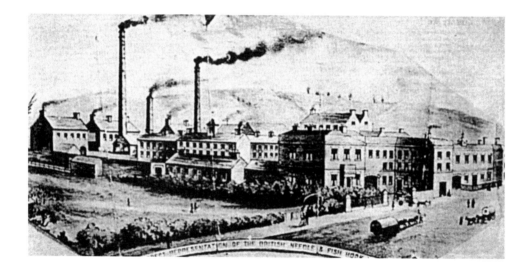

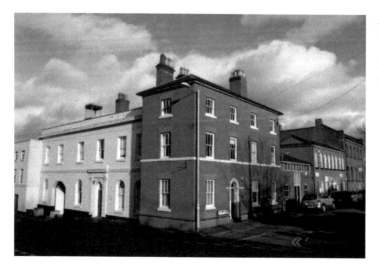

Above: British Needle Mills in 1840.

Left: British Mills today.

of Worcestershire. He became one of the first big ironworkers to move to Redditch. He built British Mills, the largest needle mills in the town. It had the tallest chimneys and the glow from its enormous furnaces made the sky red at night. There's very little of the factory left now, although a remnant runs along Albert Street at the bottom of Prospect Hill. However, the lovely house known as 'The Laurels' that he built for his family is still standing. He had nine children and five servants including a cook and a nurse. You can see the house on your right if you walk down Prospect Hill. It stood next to the factory. Later, his son and his family lived next door.

Excelsior Works

The story goes that in 1835, the Redditch toll house was empty, so a Studley needle maker, John James, moved in and began his needle business there. He made so much money that he was able to build Windsor Mills in Clive Road, also known as Excelsior Works.

There's a life-sized portrait of him in Forge Mill museum with his fishing gear, but don't be taken in by the painting. He never went fishing.

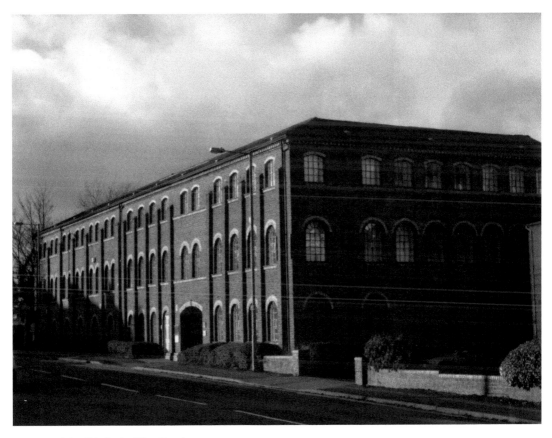

Excelsior Works in Clive Road.

How Royal Enfield Began

Between 1910 and 1920 there were beef roasts outside the Red Lion at Hunt End. Photographs from the time show it was very popular. It is still Hunt End's local pub. Here, only a few doors away from the Red Lion, Royal Enfield began.

By the 1800s England had become a gin-sodden nation. The government was anxious to get people off gin and on to beer, which was healthier, so the laws were changed so that anyone of good character could sell beer for a cheap licence. George Townsend was one of those who took advantage of the scheme. He was a young needle maker from Alcester. His black iron vat stood outside the Red Lion for many years. He made enough money to build a small needle factory that he called Givry Works, after a dear friend. It began with sixteen men and two boys but by 1871 he was employing 170 men.

George Townsend died in 1851. It was his son, George Townsend II, who spotted the potential of bicycles with two wheels. They were a great success. However, in 1890 he decided to install underground boilers and went bankrupt. The bank brought in two men to run the factory. The first was a brilliant designer, Robert Walker Smith, the other was a popular salesman, Albert Eadie. Their first large order was from the Royal Small Arms Company in Enfield, Middlesex, which explains the name Enfield. The Royal was added because Albert Eadie thought it sounded posh. The company flourished, moved to a large site in the heart of Redditch and made motorbikes as well as bicycles.

The End of Givry Works

In the early 1960s, a little old factory stood near the bottom of Enfield Road. This was the remains of Givry Works and was used to store Dunlop tyres.

The factory came to an end in a most spectacular blaze. Fire engines arrived from all over the county. Enfield Road was roped off and no one was allowed in or out. Employees who lived miles away saw the blaze and went to investigate.

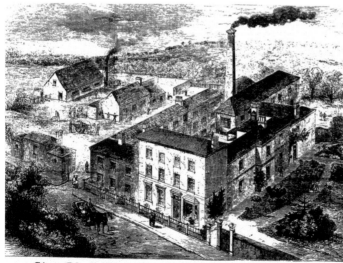

Givry Needle Works, Hunt End, Redditch. circa 1865.

Givry Works in 1865.

Apparently, one of the workers liked a hot dinner so each day he would bring his raw ingredients and a frying pan, go up to the top floor, lay out a large tyre, put his little paraffin stove in the middle of the tyre and cook his lunch. On that particular day, he fell asleep.

It was a sad day for Redditch. This is where Royal Enfield began and where Scott Atkinson founded the first English factory to make batteries. During the First World War bomb cases had been made here and during the Second World War it came into use again as one of the five Royal Enfield factories making armaments.

All that now remains is a low crumbling wall near the Red Lion. However, an identical factory was built at the same time at the other end of the road and the frontages are still standing at Nos 62, 64 and 66.

Ashley Mill, Nos 62, 64 and 66 Enfield Road.

8. Not Just About Needles

How Nathaniel Mugg Saved St Stephen's

When Henry VIII's men demolished Bordesley Abbey in 1538 they didn't touch Bordesley Abbey chapel and left it standing. However, Lord Windsor made up for that by keeping his cows in it. By the beginning of the 1700s it was in a poor condition.

Next time you go into St Stephen's Church (it's in the centre of Redditch), look for the brass plate commemorating Nathaniel Mugg. He gave enough money in his will of 1764 to have St Stephen's rebuilt and cared for over the coming years.

By the end of the 1800s, St Stephen's was in need of expensive repairs again. Redditch folk decided that this time they wanted a new church nearer their homes. They were given £1,000 and permission to build a church in its present position on the green in the centre of the town. The old stones were reused for the new church as required by law.

After the new St Stephen's had been built, the villagers needed to get rid of the old church. Demolition experts were expensive so instead the local authorities offered a reward of five shillings to the man who threw the first stone. Bell-ringer Thomas Lowes took up the challenge. Across the top of the roof was a line of carvings that a local farmer had said looked like a row of cow's udders. He managed to hit the carvings but,

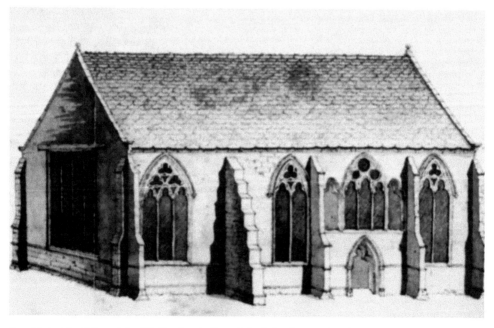

An old sketch of the original St Stephen's Chapel, built by the monks of Bordesley Abbey.

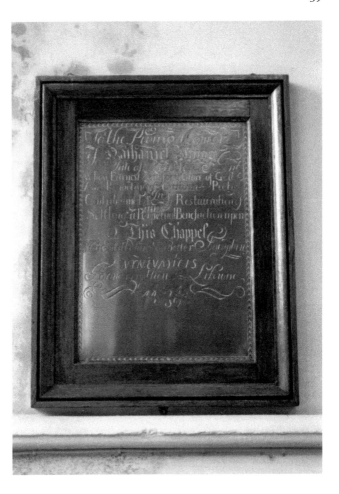

Brass plate commemorating
Nathaniel Mugg in
St Stephen's, Redditch.

unfortunately, the stone slipped from his grasp, crashed through the roof and the floor of the western gallery and smashed an effigy of the abbot of Bordesley.

The roofing tiles went to Wapping in Beoley, where they can still be seen in the roofs of local cottages. The remainder of the carvings were used as targets by stone-throwing schoolboys.

The font went to a local man, who used it as a trough for feeding his fowl. He passed it on 'in a moment of gratitude' to the son of the landlord of the Plough & Harrow, who passed it on to Robert Bartleet, one of the abbey's first archaeologists.

A local butcher hired the Bordsley meadows for his cows. This shocked the villagers and one of them wrote: 'Six hundred years of consecrated ground of Bordesley meadow was let to a butcher, and the fat bulls of Hereford came up into what had once been the inheritance of the Lord.'

The old churchyard continued to be used for burials, usually by relatively poor people who could not afford to pay for a gravestone. They hacked chunks off the old gravestones that lay around the site, then they inscribed them with the date of the person's death. They are still there, a rare and poignant example of the graves of the poor.

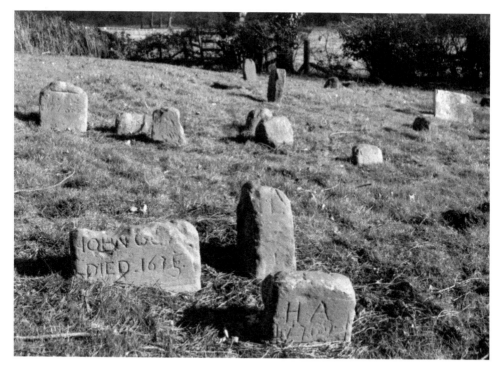

Old St Stephen's graveyard.

Astwood Bank Farm Notice

A stern warning sign was for many years attached to the roadside wall of Astwood Bank Farm, which is situated near the top of Astwood Hill on the road to Feckenham. It threatens a fine of up to forty shillings from anyone damaging the road or footpath in any way, including 'locking down any hill without a skidpan' (forty shillings is around £200 in today's money).

A skidpan was an iron-capped beam, slightly longer than the wheel's radius, hinged under the axle of a wagon in such a way that when released, it struck the road. This caused the beam to be wedged against the axle, slowing down the vehicle's forward progress. The sign was removed for safe keeping.

The state of Britain's roads in the late eighteenth century was appalling. One writer at the time commented that he had measured some of the ruts and found them to be 4 feet (122 cm) deep and full of muddy water.

Heavy loads were pulled by teams of up to eight horses. The wagons had extra wide wheels, intended to prevent the creation of deep ruts, but, instead, on roads with a firm surface they ground the gravel and stones to dust.

Each parish was responsible for the upkeep of its roads, but as most travellers were passing through and made no contribution to the cost, there was little incentive to pay for the repair of the roads.

Turnpike companies, of which there were many in the Midlands, generally improved the situation, although some were more interested in turning a healthy profit than improving the state of the roads.

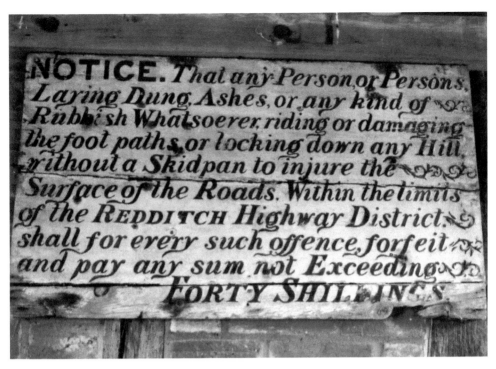

The sign, once attached to Astwood Hill Farm wall.

The Why Not

The Why Not pub at Astwood Bank is named after a horse that won the Grand National in 1894. The first Grand National at Aintree was held in 1839 when a horse called Lottery was the winner. The course then was rather different to today. The horses had to jump a stone wall, cross some ploughed land and jump two hurdles.

Horse races in this country before the eighteenth century were usually run between two horses. There were few, if any, rules and it was not unknown for jockeys to attack competitors' horses with their whips or kick them with their legs.

Austrian composer Joseph Hayden wrote an account of a day he spent at Ascot in the 1790s:

These horse races are run on a large field especially prepared for them, and on this field is a circular track two miles long. It is all very smooth and even. Among the straights, stalls of various sizes have been erected, some of which hold 2 or 3 hundred persons. The places in these stalls cost from 1 to 42 shillings per person. The riders are very lightly clad in silk, and each one has a different colour, so that you can recognize them more easily. Each one is weighed in, and a certain weight is allowed him in proportion to the strength of the horse, and if the rider is too light he must put on heavier clothes or they hang some lead on him. The horses are of the finest possible breed, light, with very thin feet, the hair of their neck tied into braids, the hoofs very delicate. As soon as they hear the sound of a bell they dash off with the greatest force. Every leap of the horse is 22 feet long. These horses are very expensive. The Prince of Wales paid £8,000 for one some years ago.

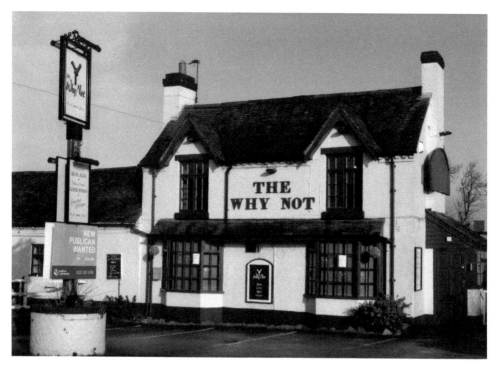

The former pub named after a winning horse.

The Railway and the Tunnel

The nineteenth century was the age of steam and the whole of England was quickly transformed with a web of railways built by private speculators.

In 1844 there was exciting news. The train line was coming to the Redditch. It was soon discovered that by 'Redditch', Midland Railway meant Barnt Green. If you wanted to catch a train to Birmingham you had first to get an omnibus from Redditch to Barnt Green.

When it first became known that the train line was to reach Redditch, a certain Mr Harrison worked out which way the line was likely to go and bought up the appropriate land.

The Redditch railway opened in September 1859. To continue building the line to Ashchurch it then needed to go to Studley, which meant crossing the Ridgeway. The question was, which was the best way to cross it? A route was suggested that could begin on the east side of Redditch and go via Hatton and WarwIck but Evesham objected strongly to being missed out, so the present route was chosen, which involved the building of a tunnel.

The tunnel, 323 metres (353 yards) long, was dug in the mid-1860s. It was said to be the greatest engineering feat that Redditch had experienced. The navvies began at the Ipsley end. First of all a small tunnel was made the length of the eventual tunnel and large enough to take a railway waggon. The workers would make holes in the ceiling above so that the soil would drop down into the waiting wagons. Eventually, these holes joined up to form the tunnel. The construction usually went well when the soil was dry but it was dangerous when the soil was wet after a shower of rain. However, the men insisted on working through all weathers. There were several accidents and in October 1867 a workman was killed.

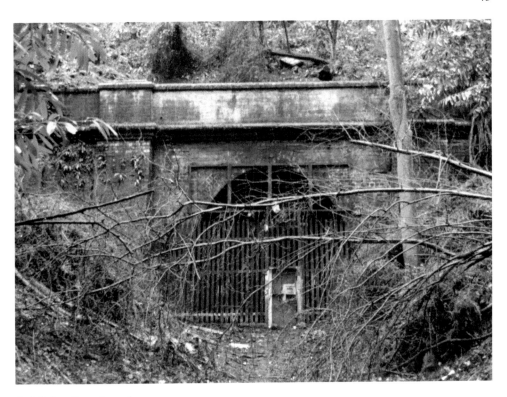

Redditch railway tunnel.

Stations

Redditch had to wait until September 1859 for a station. The station has moved three times. The first station was in Clive Road where the line divided into a number of tracks, one of which led to the coal depot at the end of the road. The Railway Inn was then built next to the station and got left behind when the station moved to the bottom of Unicorn Hill. Produce, grown extensively in the Vale of Evesham, travelled by train to distant markets. Coal from the large stocks held at Redditch travelled in the opposite direction.

Travel by train became popular not only for people but also for a whole range of animals – sheep, cows, horses, not forgetting boxes of chickens and ducklings. A larger reception area was required so the station was moved 100 yards down the line to the site of the present bus station. Ian Hayes used to tell the story:

> One morning we were joined by an additional passenger, there had been a circus on the Beoley Road ground over the weekend and the elephant was to be transported to the next venue in a large livestock wagon. This was hitched to the back of our two carriages. Apparently, allowance had not been made for this as regards steam pressure and we stalled at Grange Lane. The grumbling of the regulars was bad enough but the protestations of the elephant were something else.

In 1992 the line was electrified and new houses now stand on the site of the old goods yard.

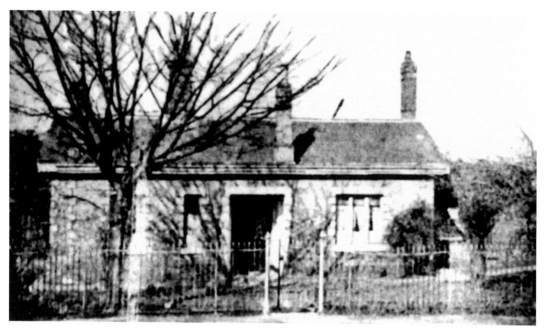

The first station in Clive Road.

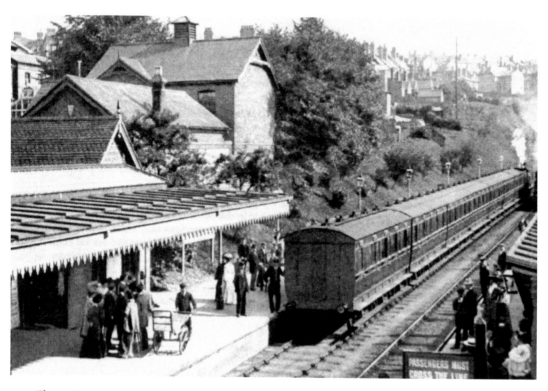

The station in 1912, site of the present bus station and car park.

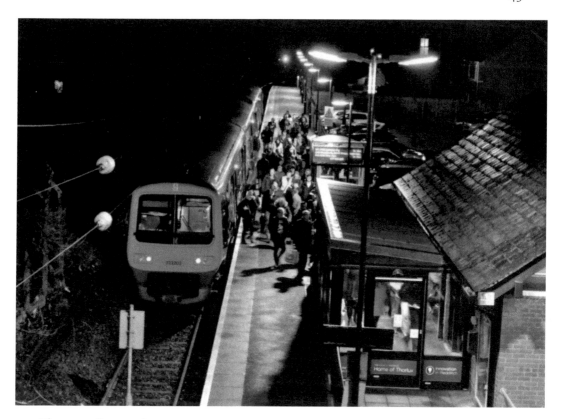

The new railway station.

9. The Second World War

This was a war like no other war. More than thirty-three countries took part. Three people in every 100 died, not only in the fighting but also by disease or famine.

The Mysterious Gravestone

Lying in deep shade halfway up the south side of the Plymouth Road cemetery is a lone war grave. The inscription on it reads:

<div align="center">

153772 Aircraftsman 2nd –CL

P W Kuck

Wireless Operator/Air Gunner

Royal Air Force

19th February 1941 Age 22

</div>

Peter Kuck was training as a wireless generator gunner when his Whitley bomber crashed. In the United Kingdom, a total of 57,205 members of RAF Bomber Command and their attachments were killed or posted missing.

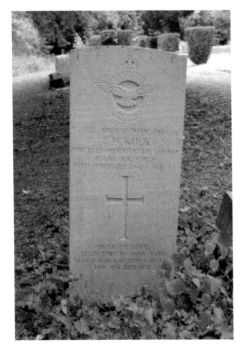

The grave of Peter Kuck.

Peter was of German descent. His grandfather, a needle maker from Aachen, came to Redditch to install new machinery at Millward's. He met his wife there and settled in the town.

When war broke out, Peter volunteered to join the RAF. Apparently there was no family concern about him taking arms against the country of his ancestry, although the RAF asked him if he wanted to change his name in case of problems if he were shot down over Germany, but he refused.

On Wednesday 19 February 1941, he was flying from RAF Pembroke Dock when it crashed into Cardigan Bay. Being a Roman Catholic, his flag draped coffin lay in Mount Carmel church overnight prior to his burial in Plymouth Road cemetery the next day.

Gas Masks

Gas poisoning had been used occasionally in the First World War on the army. The government was so convinced that an attack of poisonous gases would occur sooner or later in England that it went to the expense of supplying everyone with a gas mask. If you went to school and left it behind, you were sent home to fetch it. Fortunately the masks were never needed in this country.

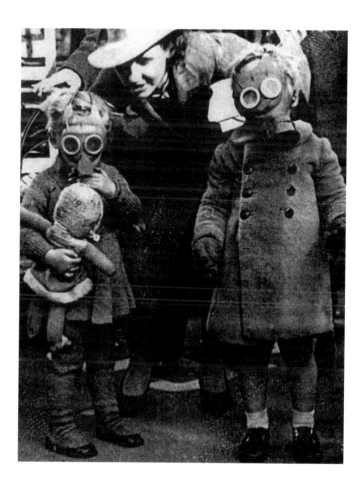

Children's gas masks were carried everywhere in shoulder bags.

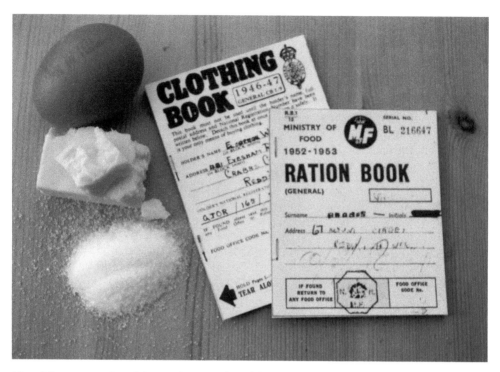

Most things were rationed during the Second World War.

A Changing Town

No other town in the Midlands changed as much as Redditch during the Second World War. The population rose from around 11,000 at the beginning of the war to around 26,000 at the end. Not only did those factories already in Redditch expand but several

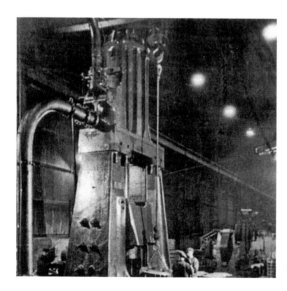

The Erie hammer.

large factories were moved here. One of the largest was High Duty Alloys, moving here from Slough where they employed 2,000 people. During the war, High Duty Alloys turned out thousands of pistons, crank cases and airscrew blades every week for Rolls-Royce and Bristol Engine Company. The 28-acre site by the railway station was chosen because it was near the gasworks and had a good supply of water. The ground was damp and it was hoped that it would muffle the blows of the Erie hammer, one of the largest hammers in Europe. When it stamped on a piece of aluminium, the whole town shook. Unfortunately, the damp ground didn't muffle the blows; instead, the hammer sank and had to be moved.

The Workers

By 1941, 4,000 workers had been drafted into Redditch. Many of them came from centres of high unemployment such as Scotland and Ireland. Most of them were young girls in their late teens, who were usually given work in factories on capstans and milling machines.

New arrivals were billeted everywhere. The Red House, next door to the old Smallwood Hospital, became a hostel, complete with a matron. Herbert Terry's house by the Holloway was also used. There was a YMCA outside the old Danilo cinema. There were two community clubs on Prospect Hill: No. 29 was for women and No. 6 (Fish Hill House) was for men.

2,000 workers moved to the 28-acre site by the railway station.

An entire new village was built to accommodate the new arrivals. Hastily put together from asbestos sheets, the site stretched back between the old Birmingham Road and Fishing Line Road. Sainsburys has now been built on part of the site.

There's a saying that marriages are made in heaven but during the Second World War many were made in Redditch; for example, Betty and Ron Passingham, and Frank Cardy and his wife. This is how the Clements of Astwood Bank met. Mrs Clements says:

> To get to my work place at Royal Enfield, I had to pass the toolroom and sometimes I could see through the long window this very nice young man standing at his bench. I was therefore on a nodding acquaintance with him and I got to know him better when I started going to the dances held in the canteen on a Saturday night. They were quite popular and about 150 people went. I was a real Black Country lass and Jack was fascinated by my accent

There you are girls, if you want to 'pull' try a Black Country accent.

The Home Guard

During the war, every able-bodied person was expected to take some part in a voluntary group to help the war effort, such as the Auxiliary Ambulance Service, the Women's Voluntary Service, Reservist Police Officer, or Volunteer Fire Fighter. The most popular organisation was the Home Guard. Mike Johnson is an authority on the Home Guard and he says:

> Forget the 'dad's army' image. This was serious stuff. If you were captured by the Germans wearing a Home Guard uniform, you were shot. You had to turn up to every Home Guard meeting and if you missed, you were fined and you could end up in prison.
>
> The Government, under Winston Churchill, decided to create a new type of army with thousands of ordinary people instead of hundreds of professional soldiers. On 14th May 1940, the newly appointed Secretary for War, Anthony Eden, appealed for volunteers. The training would be part-time and so there would be no need for them to give up their day job (ie they would be unpaid). There was no medical examination, they only needed to be able to move freely! They were supposed to be under 65 years of age but almost anyone was accepted.

Anthony Eden was amazed at the response. Within twenty-four hours, 250,000 men across England had registered at local police stations. They were first known as Local Defence Volunteers or LDVs, but later the name was changed to the Home Guard. The priority was to create a stop line to hold back any tanks and armoured vehicles, chiefly a long, deep ditch and using natural features such as rivers. There were to be three stop points in Worcestershire: Redditch, Worcester City and Kidderminster. Redditch was chosen because, in the 1940s, it stood on the junction of two important roads in Headless Cross – the Evesham Road and the road from Bromsgrove.

In 1940 the 11th Battalion of the Royal Warwickshire Regiment were stationed at Hewell Grange. Other regular army units were at The Sillins, Callow Hill and Bentley Manor.

10. Factories on War Work

The following factories employed large numbers during the war, and consequently they had their own Home Guard units: Royal Enfield, Britannia Batteries, Reynold Tubes, the Post Office and LMS Railway. So did the following factories, which are covered in more detail.

The British Small Arms Company

The BSA (British Small Arms) was a brand new factory on the Studley Road, opening in December 1938. It employed around 1,200 workers and covered 60 acres. It made the new model of the BESA machine gun, which could fire 100 rounds a minute.

Charles Stallard was Company Commander of the BSA Home Guard. He says that they drilled either at the drill hall in Easemore Road or at the BSA factory where there was a building specially for men on night duty.

He says:

> At the end of every training session all the blanks should be emptied but one night, some blank ammunition was left in one of the rifles. Two lads were playing the fool and the one lad fired at the genitals of the other lad. He was peppered with brass fragment and had to spend some time in hospital.

Alkaline Batteries (in Union Street)

A Swedish company invented a new type of battery that didn't need to be plugged in: the nickel cadmium battery. In around 1922 they moved into the old Royal Enfield factory at Hunt End that had become vacant. There, they employed around 1,000. They later combined with the Britannia Batteries in Union Street to become Alkaline Batteries. After a series of name changes they ended up as Chloride Alcad. The company moved back to Sweden in 1993 and the site was cleared.

Terry's Springs

Terry's Springs made thousands of small Anglepoise lamps for bombers, as the design was ideal for navigators' chart tables. So well made were these lamps that when, in 1986, a Second World War Wellington bomber was raised from the waters of Loch Ness, not only was the lamp intact but when fitted with a new battery, it still worked. Terry's Home Guard were part of the F Company of the 9th Battalion. Bill Hay remembers:

> There were about 150 men, Herbert Terry's two sons were also in the company. The HQ was a canteen at the top of Millsborough Road. We were provided with camp beds, we could also get tea and if we were lucky, six penny worth of chips from the local chip shop to make chip butties.

Royal Enfield, the Secret Factory

When war was declared Royal Enfield workers were in their element. They had a team of brilliant designers. They made, for example, a bike christened the 'flyjng flea' that was so strong and light that it could be dropped by parachute then be ready to be ridden straight away.

During the war Royal Enfield expanded into four factories. First, the main 31-acre site in the heart of Redditch; secondly, a small needle factory in the centre of Feckenham (now a private house); and thirdly, a small factory in Edinburgh. Not many people know that it had a fourth factory, a huge complex of stone quarries 90 feet underground in a disused mine at Westwood near Bath. Although situated in Westwood, it was designed, built and staffed by Royal Enfield and codenamed Enfield Precision Engineering. It was so secret that all of its employees had to go once a week for an hour's sunray treatment so that the enemy didn't guess from the pale faces that there was an underground factory nearby.

This underground factory was used chiefly for the manufacture of the 'predictor', a machine that could calculate the speed of a target so that it rarely missed. The engineering was precise, therefore the site had to be without vibrations. The underground site was perfect.

The Feckenham factory today, now residential.

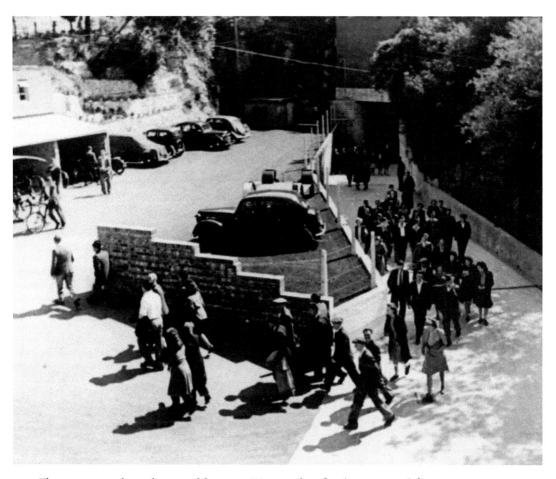

The entrance to the underground factory at Westwood, 90 feet (27.43 metres) deep.

Village Units – Headless Cross Home Guard

Many villages also had a Home Guard unit. Headless Cross Company was in rooms above Morris's shop. During the war it was the Co-operative store. Sergeant Bill Preece says that they used the long room at the back of the White Hart for target practice. Albert Wharrad was also a member. He says:

> One of our exercises was carried out on the Evesham Road where the mini island is at Headless Cross. There are shops on the right hand side and a member of the Home Guard lived over one of these shops. We had to run a clothes line from the bedroom window of his house to the house opposite, to which we attached a runner. Attached to the runner was an old blanket soaked in paraffin. We had to set fire to the blanket then suspend it over the middle of the road, the idea was to drop it on a German tank. It was a serious business. People thought the Germans were going to invade. They were only 22 miles away across the channel.

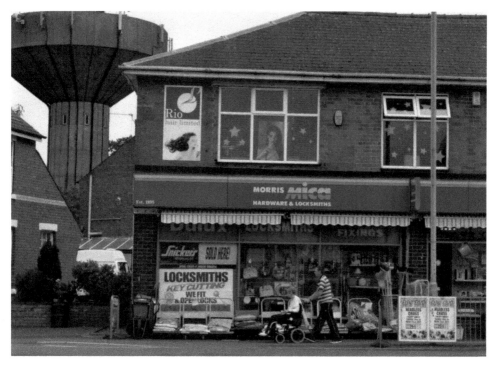

Home Guard meetings took place above this shop in Headless Cross.

The Big Invasion

To keep the Home Guard on its toes, a mock invasion was planned. The Army Units were to be dressed in enemy uniforms and carry enemy ammunition. It was a major exercise, the most important one of the year. Reg Higgett and his companions took part. He said:

> The telephone at the Rectory in Ipsley was manned in order to report to HQ on the approach of the enemy. Unfortunately, the Vicar, the Reverend Wesley Kings, was in an unco-operative mood, he had apparently been told off by the Home Guard on a couple of occasions for showing lights in the Rectory after dark. He came downstairs at about 7pm and he asked if we could be quiet so as not to wake the girls. You can imagine my surprise when 'the girls' appeared in the morning, they were all about 70 years old!

Notice: What to Do in the Event of an Invasion

This is a transcript of Egbert Ganderton's entry in his notebook 1940.

> What to do in the state of emergency ie the enemy have landed in this area. The Sections will be regrouped as follows:

ON THE HEARING OF CHURCH BELLS
Group 1. All Home Guards not at work and living within walking distance of the Works, shall put on their uniform and all equipment that has been issued to them, including

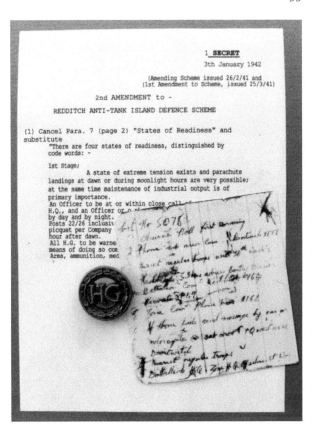

What to do if the enemy invades.

their civilian duty gas-masks, and proceed to the Works, they shall carry in their haversacks sufficient food to last them for 24 hours, and in addition, as much tinned food as they can afford to carry, with tin-opener, corkscrew, knife, fork, spoon, enamelled cup and plate, towel, soap, toothbrush, shaving tackle and a spare pair of socks.

Group 2. All Home Guards not at work and living so far from the Works that they normally travel by cycle, car or bus, will dress and equip themselves as above, and attempt to proceed to the Works. They must use all efforts to get through, but if they find that it is impossible to reach the Works by reason of the roads being blocked, they shall return home, and place themselves under the command of the nearest Home Guard Officer.

Group 3. When this state of emergency is reached, the Home Guards then at work will be informed by loud speaker system. And they shall immediately fall in on the parade ground between the office block and the Sub Station.

COOKHILL POST 5078
1-Church bell first warning
2-Phone sub area Com Droitwich 2177
3-nearest regular troops are 30ᵗʰ Warwicks

Roadblocks like those at Coughton ford were placed at vulnerable crossings.

Redditch 534, address Bentley Manor
4-Battalion Comdr Redditch 764, Private 849?
6-If phone fails send message by car or
Motorcycle
7-Battalion HQ Zone H.Q.18 Silver St Worc.
Meet Military Intelligence officer at Cookhill School.
Open fire on enemy if can do so from immediate vicinity of post.

Shoot Him!

One of the most important discoveries of the war was developed in a quiet field at the back of Astwood Bank Baptist Church.

The locals knew something was up when, early in the 1940s, a military official called on the Baptist minister of Astwood Bank and asked who owned the field behind the church. The owner was Ken Waldron, who lived at Forge Farm, Cook Hill. 'Tell him', said the official, 'That we need the field for military purposes'. 'What if he doesn't want his field used for military purposes?' asked the Baptist minister. 'Shoot him' was the reply.

Dozens of personnel were moved to Astwood Bank and billeted with local families. Mrs Wheeler was living with her niece. A handsome young scientist, Mr Pound, was billeted with them. It was a very happy household and they enjoyed each other's company, so much so that Mr Pound married Mrs Wheeler's niece.

The Development Centre was known as the Radio Counter Measure Unit. The personnel involved were subject to the Official Secrets Act and were unable to discuss their work, called 'Bending the Beams'. Basically, a radio signal can be bent if a heavy load

The former Baptist chapel at Astwood Bank.

is placed vertically against it but there are hundreds of types of beams and innumerable loads. The job of the scientists was to jam radio signals used by the German Air Force to carry out bombing raids over England. This created a serious problem for the Germans. Their planes were unable to communicate with the personnel at the airfield.

The footpath through the field was moved to the other side of the hedge and RAF sentry boxes were placed at each end of the public footpath. One member of the Home Guard and one member of the RAF were stationed at each sentry box, day and night.

Nothing now remains of this historic site behind the Baptist Chapel.

The Spy
Notices were posted everywhere: 'CARELESS TALK COSTS LIVES.' These notices were justified. There was a spy in Redditch. This is a true story, told by Arthur Newbould.

During the war, Redditch had a control centre to co-ordinate any problems that arose such as air raids or gas attacks. The Control Centre was in the gardens of the old Council House in Mount Pleasant. One of the most important items in the control centre was the map of Redditch. It was essential that the map should be deadly accurate and kept up to date. It was a huge thing, on two rollers fixed to the wall and it was my job to keep the chart up-to-date.

A scratched-out ink stain proved that there had been a spy in Redditch.

In those days people used fountain pens that often leaked. One day, I was working on the map when my pen leaked on it. The pens were filled with indelible Indian ink. I made an attempt at scratching it out, but the surface of the chart was damaged slightly.

Time passed, and in 1947 I returned to the office in a superior post. While I was there, I received a parcel of Air Navigation maps recovered after the war from German airfields and air traffic control stations. I could not believe my eyes because among them was my map of Redditch with its scratched out stains. Someone had sent it to Germany during the war. My brain was in a turmoil for some days. There must have been a spy in the office.

The Air-Raid Shelters

Two or three times a week, usually at night, the wail of the air-raid siren would ring out, which meant that you had to tumble out of your nice warm bed and go to the air-raid shelter. You had to wait until the siren blew the all clear, one long note. Then it was safe to go back to bed.

There was a great variety of air-raid shelters, but none of them were able to save you from a direct hit. Their chief aim was to protect you from debris if a bomb fell nearby. Most people improvised their own air-raid shelter. A lot of the old houses had a cellar or a coal house. Failing that, you were advised to shelter under the stairs.

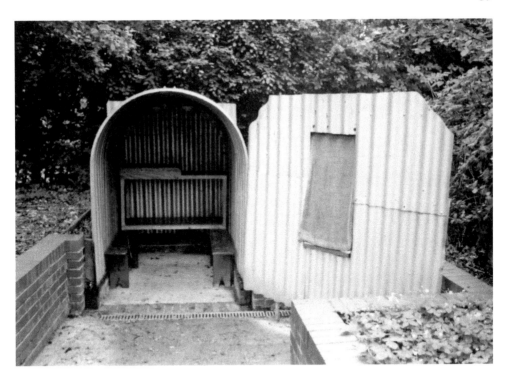

Air-raid shelter.

There were over eighty communal street shelters, brick built and capable of holding between forty to eighty people. The Home Guard had to check every one of these every night. They tried to make the British Restaurant their last call where they were given a hot dinner.

Incendiary bombs were a frequent nuisance. Terry Halford was only sixteen when the air-raid warden knocked on his door and asked him to help to put the incendiaries out. Terry said the bomb was like a big candle. One of the helpers had wrapped his hand in fireproof fabric and was waving the bomb about. The air-raid Warden shouted, 'Put it out, you mad idiot'.

A sad story is that one man in Redditch built himself a splendid air-raid shelter. It was the best in town. Unfortunately, he wasn't in it when the bomb fell and he was killed.

The Night Soil Cart

In 1879, a government enquiry was held about the sewers of Redditch and the Local Health Board was ordered to improve matters or face heavy fines. Some areas in the town were too far away from a sewer to be connected. Then the Board had a great idea: a night soil cart. New lavatories were designed with a two-handled galvanised bucket below the seat. A trap door opened behind the seat so that you could pull the bucket out and carry it, shoulder high, to the road outside and tip the contents into a cart. Every evening, as soon as it was dark, the driver would emerge with his horse and cart to do a different round

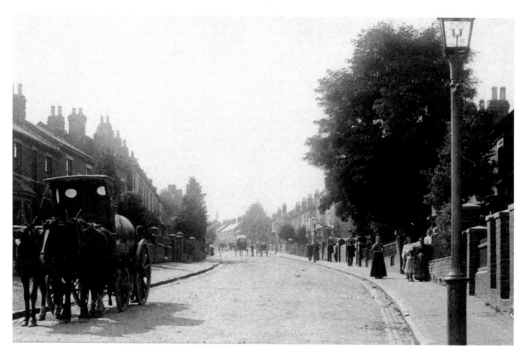

The night soil cart in 1910.

each night. The sewage made excellent fertiliser and was much in demand by the farmers. The system worked tolerably well until the Second World War when the blackout arrived.

This is from Arthur Newbould's book *Not Just Bricks and Mortar.* An army driver had collected some soldiers from Hewell Grange on late passes, then had crashed into the night soil cart and knocked cart, lid, contents and horse flying. A teenage Arthur was in charge of overseeing highway repairs and the powers that be evidently decided that this included removing slurry, so he was called out to deal with it. He says:

> When I arrived on my racer bike 'it' was everywhere and, horror on horror, half the load seemed stuck on the windows and fronts of the houses nearby. I was seventeen at the time with a wealth of experience (well just under twelve months) in my job and about four minutes experience of what to do about gallons and gallons of night soil and other items of gunge stuck on front elevations. I remember, by the light of the policeman's lamp, seeing a triangular bit of the Birmingham Post caught on the door handle of the front door. There were lots of other bits – some in the letterbox.

It was important to get it all shifted and out of sight before the squeamish went retching past to work. The police suggested that he called the fire service and asked them to sluice the mess away with their hoses. Unfortunately, the firemen used too much hose pressure and smashed the windows, sending the glass with its revolting accretion straight into the bedrooms. It was everywhere.

Arthur was hidden from public view for a few days until it had all blown over.

11. When the Bombs Fell

The First Bomb

On 2 October 1940, in the early days of the war, a Heinkel III flew over Redditch. There were three guns that could have fired at the plane: a Bofors machine gun on Lowans Hill, another in Brockhill Lane and a third at either the gasworks or the crematorium. Not one gun was fired. The gunners just stood and watched it as they didn't know what it was. When it got over St Stephen's Church, the bottom of the plane opened and a huge bomb wobbled out. It was so large that Terry Halford, who was watching, thought it was a man jumping out. Then the gunners opened fire. The bullets failed to hit the plane, but it was later shot down over the coast.

The bomb was probably aimed at the BSA but it missed and fell into the field next to the factory where it made such an enormous crater that it was later made into a swimming pool.

The Next Bomb

Late in the afternoon of 11 December 1940, a cheerful crowd in New Street station boarded the train for Redditch. It was a fine, clear evening with a bright moon. The war news was depressing but who cared, it was only two weeks to Christmas.

Then the engine driver noticed something strange. Not far from Birmingham he had picked up a plane flying closely overhead. As the track turned or went straight ahead so did the plane. It seemed to be following its tracks. When the train neared Redditch, the plane veered off to the right and disappeared. The driver breathed a sigh of relief as it seemed very sinister.

A few minutes later, a bomb went screaming through the sky. With a loud crump, it hit the ground and the station shook. Another bomb followed it, then a third. The reverberations from the bomb shook the Danilo cinema and there were remarks that it should be called the Rock House cinema. The manager appeared and advised everyone to go home.

A young local lady, Connie, had gone out to meet her boyfriend but when she got to the corner of the road she realised that she didn't have a clean hanky so she turned back home to get it.

As I went in the front door I saw my mum and dad huddled together under the stairs. My sister used to look out of the bedroom window whenever the bombs were dropping. As I walked in my sister started running down the stairs shouting 'It's coming, it's coming'. I ran to get under the stairs with my mum and dad. As I did so, the bomb came and hit us and the blast bounced my sister down the last few stairs. The house started shaking and the roof fell in.

Glover Street, one of the streets destroyed by the bomb.

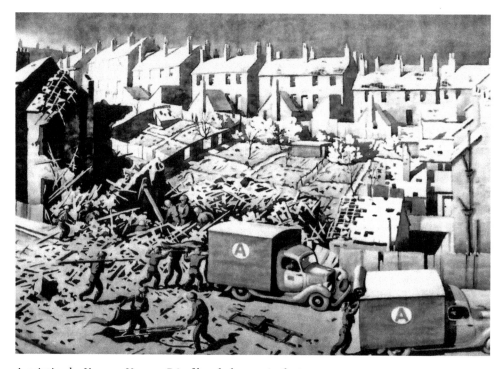

A painting by Norman Neasom RA of bomb damage in the town.

Fortunately, an air-raid warden lived a few doors away and he organised their rescue. The bombs fell on Evesham Road, Glover Street and Orchard Street. Six were killed including a seven-year-old boy. Thirty-six were injured, twelve of them seriously. One man lost everything he possessed – his wife, his baby, his house and even the clothes he wore were blown off him. His next-door neighbour was killed. A dozen houses were completely destroyed and 489 were damaged.

The bomb did peculiar things. The blast blew dust down the chimneys so that rooms were covered in soot. One housewife living nearby kept chickens in her back garden, all of which disappeared without trace – she never found a feather. Another house suffered a lot of internal damage – the windows were blown out and her crockery was smashed – but there was a basin of eggs on the kitchen dresser and not one of the eggs was even cracked.

The artist Norman Neasom was in the Home Guard and had a close-up view of everything that occurred. He painted three scenes of the war damage, two of which have been on display while a third has been lost.

12. The Redditch Development Corporation Arrives

Holmwood

Ever since the end of the Second World War Birmingham's population had been increasing and by the twenty-first century something had to be done. It was decided to use the powers of the 1946 New Towns Act whereby Birmingham's officers would find an existing town and expand it to accommodate the overspill population of Birmingham. At a final meeting in Birmingham, Redditch was chosen.

There was tremendous opposition, especially from those who lived in Redditch. Nevertheless, on 10 April 1964 the management of the town was handed over to the Redditch Development Corporation. The town was to be rebuilt and expanded from 32,000 to take as many as 78,000.

The Development Corporation arrived in around 1964 and were installed in the luxurious surroundings of Holmwood, once the local vicarage. It stood in 26 acres of garden. Purshall Avenue was originally the drive up to the house.

The whole of the new town was planned here. This is where Chairman Sir Edward Thompson expressed his dream of a new Redditch rather crudely by saying, 'We don't want a bloody Cumbernauld in Redditch' (Cumbernauld was the previous new town).

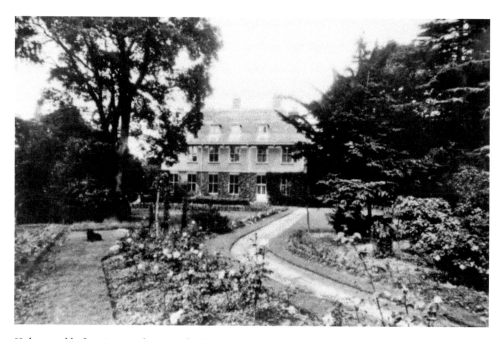

Holmwood before it was taken over by the Redditch Development Corporation.

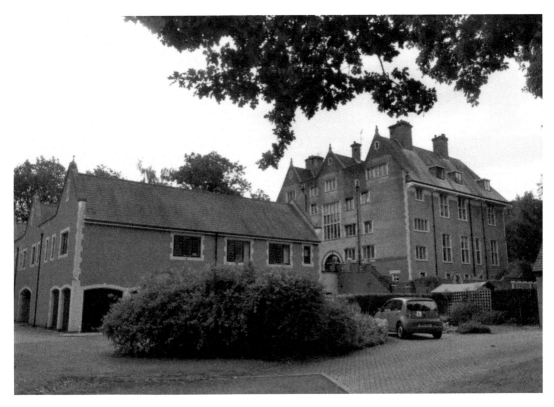

Holmwood as it is now.

How to Plan Your Financial Programme

One of the most important officers on the Redditch Development Corporation was chief finance officer Bill Evans. He had to cover a whole range of services. The Ministry wanted a draft budget from 1964 to 1966. The Civil Service demanded that it be done without referring to the experience of other towns. It was impossible to do all this.

BIll found an empty room, put a pile of blank papers in the centre of the table, asked one of his close friends, Bill Singleton (the chief engineer), to join him and locked the door.

The biggest expense would be the building of new houses. On the top of the first page they wrote 'HOUSING'.

Mr Evans asked Mr Singleton how many millions that would cost in total. Mr Singleton made a guess and Mr Evans wrote it down.

How much for sewers? Mr Singleton suggested a figure and they wrote it down. No problem.

How much for roads? No problem.

How much for factories? No problem.

That was the budget completed.

By the end of the afternoon, the five-year budget for the Development Corporation had been decided, typed, and distributed – and it worked.

The Kingfisher Shopping Centre

In the very heart of Redditch is the indoor Kingfisher Centre. When it was first opened in 1976 by then Prime Minister James Callaghan it was one of the first undercover shopping centres in the country.

Many people are unaware that today, beneath its floors, there are the streets and pavements of the old town. You may notice old names cropping up again and again. The shopping centre was built in the same position as the heart of the old town so the passageways of the Kingfisher Centre follow the old roads. For example, when you walk along Walford Walk you are moving along Walford Street as you would have done years ago, but on a higher level. Evesham Street is now Evesham Walk, George Street is George Walk and Worcester Road is now Worcester Square. Silver Street has kept the same name. All has been saved for future reference.

The name of 'Kingfisher' comes, first, from the old Temperance Hall in Worcester Road, which was turned into a British restaurant during the war and renamed, and secondly from a warship adopted by Redditch folk. It was customary for a town to adopt a battleship and send little treats to the sailors such as magazines and knitted socks. The local scoutmaster, Arthur George, had joined the Royal Navy and he suggested that the town adopted his ship, the *Kingfisher*. The name was particularly appropriate for Redditch as it was one of the few places where you might catch sight of the blue flash of a Kingfisher.

There's a model of the boat in the foyer of the Council House.

Evesham Street was the town's main shopping centre in the 1960s, before the Redditch Development Corporation arrived.

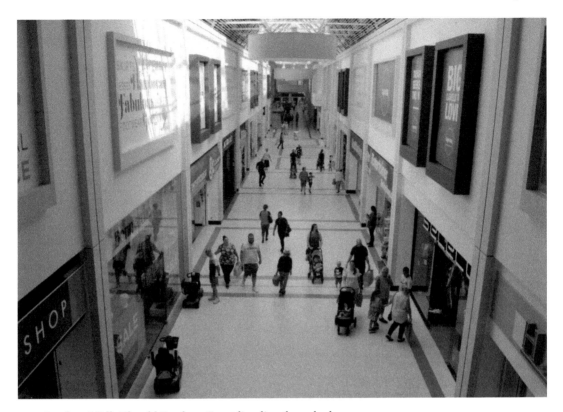

Evesham Walk. The old Evesham Street lies directly under here.

The Secret of the Foundation Stone

The Development Corporation wanted something special to attract the crowds and so it was designed like an oasis. In the centre was a small walled pool and round it were palm trees. Unfortunately the palm trees didn't survive, even though glass panels were inserted in the roof to let in more light. There were various attempts to replace and revive them without success.

If you look on the foundation stone on the front of the Town Hall, it tells you that it was laid by Redditch Councillor A. E. Jones on 11 April 1981. Terry Halford can tell you the truth and reveal the secret of when, and by whom, it was actually laid:

> Round about 1981 there was me and one or two bricklayers from Evesham working on the town hall when the officials said that some Big Noise was coming, This was a few months before the building was completed and the site was all mud and business odds and ends. We had to do a bit of clearing up, then we unrolled some sacking and laid it outside Barclay's Bank and along the entrance up to the market, for the Big Noise to walk on. In the rear entrance bay we had to leave a hole which was slightly bigger than the foundation stone which was to be laid there. Up comes the Big Noise and all the others with their black suits on. We had to lift this block of stone and put it in the hole. The Big Noise was given a silver trowel and he tapped the stone with everybody taking photos. We finished it off so that it looked nice and tidy.

The Town Hall foundation stone.

After he had gone, we took it out, cleaned it and put it in a safe for three months until the building was finished. Then it was transferred it to the front of the town hall.

So in actual fact, the foundation stone was laid in July 1981 by Terry Halford.

Paolozzi Creates the Redditch Masterpiece

In the centre of Redditch there's a famous work of art worth millions. You don't have to queue to see it as you do with the *Mona Lisa* and you can even drink a cup of coffee while you are looking at it.

It's in Walford Walk. Before the new town arrived this was one of the rundown areas, said to have rats as big as elephants in it. Walford Street is still there but buried beneath the Kingfisher Centre. It's now home to a great masterpiece of modern art. The walls are lined with twelve enormous panels, 21 feet (6.4 metres) by 12 feet (3.66 metres), made up of thousands of tiny mosaic squares. It was designed by Eduardo Paolozzi, one of the founders of pop art. The mosaics were made individually and carefully colour matched to a theme, then three craftsmen came over from Italy for two weeks to assemble them. It was opened by Queen Elizabeth on 19 April 1983.

Paolozzi was born in Scotland in 1924 to Italian parents who owned an ice-cream parlour. In 1939 war broke out and Paolozzi was interned with his mother in a prisoner of war camp. His father, uncle and grandfather were put on a boat to go to Canada that was torpedoed and all three drowned.

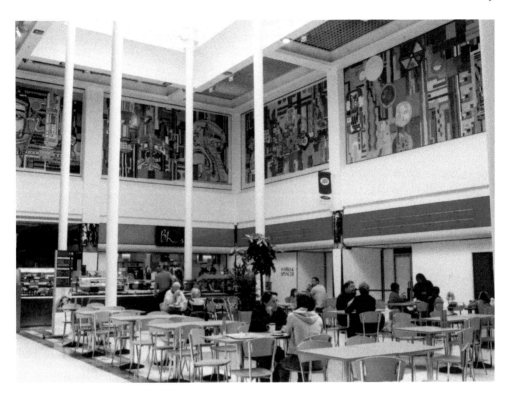

The Paolozzi murals in the Kingfisher Centre.

If you would like to see more of his work, he donated many of his works to the Scottish National Gallery of Modern Art. You can also buy an original sketch off the internet but it will set you back £1,000 or so.

The Secret Church
Sandwiched between a bank and a betting shop in Evesham Walk is a glass door. Surprisingly, it's the entrance to a modern church.

Way back in the 1800s, Thomas Williams had a little needle factory in the centre of the town in Evesham Street. He attended the nearby Methodist church but there were too many rules and regulations for his liking so he asked around to see how many would support him if he founded an Independent church, later known as Congregationalist. He had a good response so he built a church on a plot of land behind his factory. As his needle factory prospered, he added a large hall, four classrooms, tennis courts and a bowling green.

When the Development Corporation arrived one of the first questions they asked was, 'Who owns Evesham Street?' The answer was, 'The Congregationalists!' Church members were a bit surprised to find they were millionaires!

The church and its land was subject to compulsory purchase. Church members asked for another plot in the town centre in return but the Corporation said that this couldn't be done. Instead, they offered them a central area on the second floor of the Kingfisher Centre.

At that time, church attendance was falling, many churches were closing or could not afford expensive repairs. The old Methodist church off Bates Hill was having to close down and the Bishop of Worcester suggested that the Congregation and the Methodist churches combined to form an ecumenical centre. In 1976 the two churches both moved into the new town church under the name of Trinity Church. It was one of the first ecumenical projects in England and created a lot of interest.

Everything had to be divided up between the two churches – chairs, hymn books, even the ministers! They started off with two ministers, one from each denomination, but have now settled with one alternating. Strange to say, one of the most difficult things to get right was the flower arrangement. For years afterwards they still had two flower stands, 'theirs' and 'ours'.

A stained-glass window from one of the churches was placed in the centre, with the text 'Let not your heart be troubled'.

In 2003 they joined with another redundant church, Alcester Street Methodist. They all decided they needed a new name. They chose the Emmanuel Centre, 'Emmanuel' meaning 'God with us'.

The church in the Emmanuel Centre, Redditch.

What happened to the organ?

13. The Town

An Apparition in the Library

With the new town came a spacious modern library. Redditch Borough Council had wanted a new library for years but could not afford it. Then, in 1974, government policy changed and the county, not the council, had to pay for one. It opened in January 1976 in the Market Place in the centre of the town.

On Saturdays during school holidays, the library now often welcomes over 1,000 people through the doors, including many youngsters. A wide range of events attract both teenagers and young children. Manager Teresa Jordan says, 'Our position makes us a natural hub of the community. We like to take part in community events. We like to join in'.

The top two floors of the library have rooms of varying sizes reserved for meetings and are available for hire. Such meetings, especially those with a speaker and audience who are unfamiliar with the room's unusual feature, are liable to fall silent when an apparition

Redditch Library in the marketplace.

materializes in their midst. First the feet appear, then the legs and body and finally the head, slowly descending in a glass cage before sliding slowly through the floor. Grinning face, body, legs and last to go, feet, disappearing little by little like the Cheshire cat in *Alice's Adventures in Wonderland* that 'vanished quite slowly, beginning with the end of the tail and ending with the grin, which remained sometime after the rest had gone'. It is, of course, a glass lift and its occupant on the way between floors. With each appearance, the mood of the room changes from nervous surprise to a suppressed merriment, The speaker, meanwhile, struggles valiantly on.

The Hidden Theatre

You might think that the smart building at the end of Grove Street, with its imposing large curved glazed windows, is a prestigious office block, but this is the Palace Theatre.

In the early 1900s Mr A. K. Hayles came to live in Redditch. He decided that the town would be improved by a theatre, and persuaded a few friends to join him in financing and building one. There were Mr Williams, the clockmaker; Mr Shrimpton of Building Supplies; and Mr Wilkinson, the milkman. To design and build the theatre, Mr Hayles chose Bertie Crewe, an experienced theatre designer.

It opened in 1913 and since that time has presented everything from Shakespeare to dancing elephants. Performers have included Mavis Bennett (the nightingale of the

The Palace Theatre before redevelopment.

wireless), Elsie Siddele Downing's dancing school, and Alan Styler, Maurice Clarke and Wilf Johnson in light opera.

In 1954 the building closed down as a theatre and became a roller skating rink, then a dance hall, and finally a bingo hall.

The theatre was saved by the Redditch Development Corporation. They fell in love with the Palace and bought it in 1967. Apparently, Bertie Crewe had an international reputation for building beautiful baroque theatres. Although he had built more than forty, only six had survived and the Redditch Theatre was one of them. Historical experts arrived with copies of original designs and set to work. The Redditch Borough Council donated £3 million and the Heritage Lottery Fund donated £4 million.

When it was finished, the Development Corporation gave it to the town as a gift. However, Redditch Borough Council turned it down. The Corporation wanted the theatre run by a trust but Redditch Council didn't believe that there were enough rich people in Redditch to form a trust. Finally, Redditch Council agreed to accept the gift if it were to be run by the council. To celebrate, the Development Corporation arranged for a grand opening, with a special guest, Peter Walker, Minister of the Environment. Unfortunately, they forgot that Peter Walker was Conservative and Redditch at that time was strong Labour. To compensate they organized a second opening, and a third.

The Palace Theatre at night.

14. The Satellite Villages

Paradise

The Development Corporation had to build accommodation for between forty and seventy people per acre. The new housing estates were Greenlands, Woodrow, Lodge Park, Oakenshaw, Winyates, Matchborough and Church Hill. They were usually known as 'satellite villages' because each estate was designed with all the shops necessary for day-to-day living in the centre so that there was no need for the elderly or the disabled to travel into Redditch.

Josie Goodread, her husband and three children moved into the first new Development Corporation house from a Kings Norton flat. She said:

> When we first moved here, it seemed like paradise. We could watch the children playing from my kitchen window and my husband would take them for long walks, they had the

Shopping centre at Matchborough.

brook, the woods and the fields. It was quite a culture shock coming here, it was so quiet that we couldn't sleep at nights – there are no street lamps. Everything was laid back and slow. When you travelled on a Corporation bus in Birmingham, as soon as you passed the stop before your destination you had to get up and dash to the front. We started to do the same here. The locals waited for the bus to stop before getting up. They used to look at us as if we had gone mad.

Matchborough was a typical satellite village. It had, in addition to the usual variety of small shops and pubs, a public toilet and a telephone box. Parking was at each end of the village and it was served by a bus route.

The new church at Matchborough was paid for by the Anglican and Methodist churches to be used jointly. It was briefly famous in 1970 when Revd Elizabeth Mayes, a Methodist minister, was chosen as its minister. At the time, there was heated controversy in the country about women administering Holy Communion. The Bishop of Worcester made clear his support for her by attending her first Communion service and receiving Communion from her.

The Grim Story of Moons Moat

The Redditch Development Corporation recognised the historical importance of Moons Moat and the site has been preserved. Grants in 1973 from the Development Corporation and the Ministry of Works paid for excavations that revealed the foundations and walls of a medieval moated manor house, possibly dating back to the 1200s. Its history is a spine-chilling story involving three murders, going back to 1692 or 1693.

The villain of the story is Lord Baron Mohun (pronounced 'moon'), a sordid, drunken teenage ruffian who lived in London. His partner in crime was a certain Captain Richard Hill. One evening, they went to the Drury Lane Theatre and both fell madly in love with the lovely young star Ann Bracegirdle. They found out where she lived and went to visit her but her mother managed to get rid of them. However, on the way back to their home, very drunk, they came across the star's boyfriend and, uttering bloodcurdling threats, they decided to get rid of him. While Lord Mohun held the boyfriend, Captain Hill ran his sword through him.

Captain Hill was then wanted for murder and had to lie low. Lord Mohun evidently advised him to hide in his old moated farmhouse at Moons Moat. Already living there was Joan Moon, a widow, her three sons and their half-sister, Mariolle.

On 14 January the Beoley constable, PC Richard Gale, happened to be passing the moated house late at night when he heard a scream, followed by another scream and a splash as if something heavy had been thrown into the moat. It was then too dark to search so PC Gale went back the next morning but found nothing suspicious. However, Mariolle was never seen again.

On 15 January a smart young officer arrived at the Angel in Alcester. He was friendly and well spoken, and local people invited him to their social events. One evening, he had too much to drink and there was a quarrel over a pretty girl. He drew his sword; that was too much for the locals, who escorted him back to the Angel and disappeared.

Moons Moat in midwinter.

Mysterious bumps and groans could be heard in the room where Captain Hill had slept. The house began to have the reputation of being haunted.

Nearly a century and a half passed. Then in 1837, the inn closed to be converted into a private house. At the back of an old oven a travelling box was pulled out. In it was a warm cloak, a low crowned felt hat, some ornamental buckles, a snuff box, two rusty swords and two letters to Captain Hill about loans.

The captain was never seen again.

15. Local Industry

Each satellite village had a corresponding factory area. Woodrow had Park Farm, Matchborough had Washford, and Winyates had Moons Moat South and East. Altogether, there were thirteen industrial estates comprising 450 factories. When allocating a rented house, priority was given to those who were starting work in Redditch.

In 1979 James Thacker arrived to oversee the local industry. It was his job to convert a failing old town into a profitable new one. He was there for nineteen years.

It was a time of unemployment and there were five applicants for every job. New factories were being built in Redditch and they needed employees. James carefully interviewed each applicant but nevertheless he managed to employ the biggest villain in England who promised to build the fastest speedboat on record. He showed hundreds

Small factory units off Park Farm.

Halfords Support Centre in Icknield Street.

of complicated drawings to wealthy prospective customers, insisted on extravagant advances, but no speedboat ever appeared.

Different sizes of floor space were on offer and so James introduced a ladder system. If someone took a small unit then began expanding, James almost immediately gave them a larger unit. There were also those who wanted to start up their own businesses. James said: 'I looked for someone who had worked locally, knew the trade and wanted to set up on his own. They were the most promising'.

Some larger companies moved to Redditch such as Halfords, the cycle company. The biggest employer was AT&T Istel. By the 1980s they were employing between 1,500 to 20,000 people.

Schools – Up Lady Harriets

In 1932, a grammar school of around 1,000 pupils was founded in Redditch. In 1971 the county decided that it would go comprehensive. In Redditch, this meant three tier. There were first schools from five to nine, middle schools from nine to thirteen and high schools from thirteen to eighteen.

In 1974 the grammar school became comprehensive and was renamed the Abbey High. In 2001 the Abbey High School was closed, reopening as Trinity High School and

Lady Harriet, Baroness Windsor.

Sixth Form Centre. In 2004 Trinity became a business and enterprise specialist school. In August 2011 Trinity became Redditch's first Independent state-funded academy.

For each change it has been necessary to find a new name. For the first change in 1974 the staff were enthusiastic in their search for an appropriate and pleasant name and many suggestions were put forward in the staff room. Then one of the staff noticed that Lady Harriet's Lane ran along the back of the school. Here was an appropriate name and a pretty one. Almost unanimously, the staff decided that this was the name that they would put forward to the governors. Then, at the last minute, the PE teacher breezed in. Although she was not very tall, she was well built and muscular – not a person to be argued with. 'Absolutely no way', she thundered. 'I am not having my girls in the hockey matches cheered by a crowd shouting "Up Lady Harriet's!"'

16. The Green Town

There are more trees in Redditch than in Sherwood Forest! The man who was chiefly responsible for the town's landscaping is Roy Winter of the Redditch Development Corporation, who was working in Redditch from 1965 to 1985. Roy's many awards for his work on the town included, in 2004, the Landscapes Institute Midland prize for the most influential architect within the past twenty-five years. Roy moved to Redditch in the mid-1960s, not only to design the landscape of the whole town but also to rebuild (as his home) a derelict Queen Anne cottage on the outskirts of the town. He was accompanied by his artist wife and a young baby.

Windmill Drive in spring.

Stepped flats on a steep slope near to the top of the Ridgeway.

The Evesham Road – Buses Only

One of the first things the Development Corporation did when they arrived was to turn Evesham Road into a buses-only lane. A sign was erected at the end of Evesham Road near Crabbs Cross island, saying 'BUSES ONLY'. Nobody took any notice of it.

Opposite Crabbs Cross post office is a small car park. It was not designed as a car park but was intended to be the start of a through road taking general traffic all the way from Crabbs Cross into the centre of Redditch. The Evesham Road was to become a buses-only route. However, there was an uproar. Evesham Road was an ancient and historic ridgeway – woolly mammoths once wandered along here. Between Crabbs Cross and Redditch were a range of essential businesses, including a garage, two fish and chip shops and more than twenty pubs. Where could you buy your tin bath if Morris's hardware store closed, and where could grandad get his flannelette pyjamas if he couldn't reach the haberdashery shop at Headless Cross?

So the Development Corporation had to give way, but the sign, 'BUSES ONLY', stayed up for several years. Like the 'ICE ON THE ROAD' signs that you see in August, it was probably no one's job to take it down.

Crabbs Cross island and Evesham Road.

Car park, Crabbs Cross. The road to nowhere!

Redditch is claimed to have the UK's only clover leaf junction.

The Clover Leaf Junction

Where the A441 (Alvechurch Highway) meets the A448 (Bromsgrove Highway) and the A4189 (Warwick Highway) there's a new kind of junction. From the air, it looks like an enormous clover leaf and is therefore known as a 'cloverleaf junction'. This junction has been the butt of many jokes. One comedian said that Redditch is the town where you meet little old ladies driving the wrong way round traffic islands. Another joker said that the crime rate in Redditch is very low because villains can't find their way into the town.

The Mysterious Hill

Driving along the Birmingham road, the A441, towards Redditch, you pass the junction with Dagnall End Road on your left, then Weights Lane on your right and just before you

Redditch's ski slope.

reach the main traffic island, there's a curious grassy mound on the left beside the Abbey Stadium. There were discussions about having it excavated. Then the truth came to light. It's our ski slope.

What had happened was that a local councillor owned a building company. He bought a 3-acre field for housing but needed to lay drains and generally lower the height. It would involve removing tons and tons of earth. What could he do with the earth?

Then he went to Switzerland with his family. He didn't ski, but he watched the youngsters and an idea struck him. Why not create a ski slope in Redditch? At the next council meeting he outlined his proposal. As a councillor, he was always being urged to provide facilities for exercise and sport.

The soil was duly delivered, and hundreds of lorry loads trundled precariously up the slope, making a hardened pathway.

Winter came and work stopped. When spring arrived, everyone noticed that the hill had shrunk a little. After a warm spell it shrank even further. A member of the Soil Association was called who gave the sad news that it was the wrong type of soil.

As the years passed, the slope became smaller and smaller until it reached the size that you see today. It really doesn't matter, as the area previously was flat and very boring. The hillock gives it some relief.

The Coldest Spot in Britain

On the hottest of summer days, temperatures in one small area of Redditch fail to rise above freezing point. Even its name, Coldfield Drive, recognises the fact. On the hillside, near to the road, is a tall conifer tree, its dark green leaves permanently covered in frost.

Closer inspection, however, reveals the foliage to be made of plastic with the frost sprayed on. The tree's massive trunk appears to be moulded concrete. The illusion is finally dispelled by a cylinder rather clumsily attached to the top of the tree. It is, of course, a telecommunications mast.

Attempts to disguise such masts are quite common in the town, most frequently as upside down street lighting that has lost its lights.

The designer's imagination, however, went wild with Coldfield Drive's Christmas tree.

Unlike lightless street lamps and the evergreen tree, Redditch water towers make no attempt at disguise. Both the Headless and Astwood Bank water towers have their crowns adorned with a rich variety of ironmongery, proudly displayed and visible from miles away.

Forever winter in Coldfield Drive.

17. The Arrow Valley

A Dangerous Ford

The River Arrow runs through the whole of the town, dividing the western side from the eastern. Much of the soil in the Arrow Valley is non-porous red clay, which holds water instead of allowing it to drain away. Consequently, Redditch is subject to flooding.

Sometimes, in the past, this excess of water has been downright dangerous. The River Arrow crosses the old road to Beoley where it was known as 'Beoley Brook'. Sometimes, millers at Beoley Paper Mill or Beoley Mill upstream opened the floodgates to release floodwater. It would then become an unstoppable wave surging downstream, making Beoley (Brook) ford impassable. In 1820 the local carrier, Mr Heath, lost his son and two horses. Henry Garfield was drowned there in 1861. In 1810 five horses belonging to the Birmingham Brewery were swept away, and another horse was lost in 1825. There's a tradition that the founder of the Methodist movement, Charles Wesley, was nearly drowned there in a flash flood.

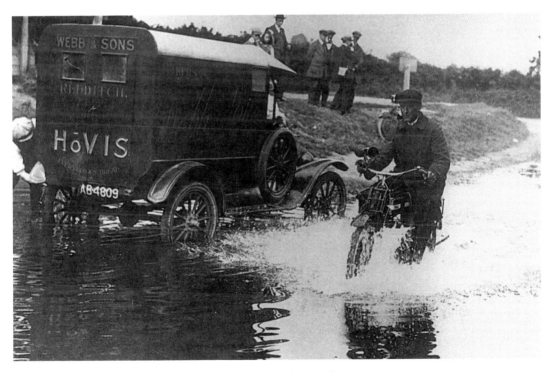

A motorcyclist passes a man washing his van in Beoley Brook.

Beoley Brook ford (the River Arrow).

The Arrow Valley Park

The Redditch Development Corporation had to find an answer to the flooding. The solution lay in the area between Bordesley Abbey meadows in the north and Ipsley in the south. They earmarked 900 acres (3.64 square kilometres) to convert the area into a park.

A boy fishing in the River Arrow in 1905.

The same scene over a hundred years later, showing a young man fly fishing.

Today it makes a pleasant walk or cycle ride from Bordesley Abbey to Washford Mill near Studley, on tracks that are carefully laid out. From Bordesley Abbey the river flows in an easterly direction at first but abruptly turns southwards at a place called 'The Five Tunnels'. An air of mystery hangs over these tunnels. You may be approached by strangers who, with lowered voices, ask if you have seen the five tunnels. The banks of the Arrow at this point are around 2.2 yards (2 meters) high and are pierced by these five tunnels, each one just under a yard (around a metre) in diameter. No one knows for certain their purpose. It has been suggested that they were some sort of overflow for nearby Beoley Paper Mill.

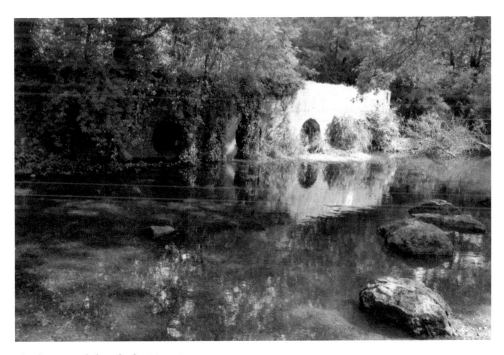

The five tunnels beside the River Arrow.

The Three Mills

Walking through the Arrow Valley park you pass three mills where the millponds still exist, although none are now used.

Paper Mill Farm, also known as Beoley Paper Mill, has parts that are so old that it was probably built by the monks of Bordesley Abbey. Until 1940 the mill made blue paper, used for wrapping needles. After 1940 it made all kinds of paper, then closed in 1951. The main road next to it is aptly known as Paper Mill Drive.

Passing under the busy Coventry Highway, you enter the Arrow Valley Country Park and its lake. On the left is Beoley Mill (not to be confused with Beoley Paper Mill further upstream). The two names (Beoley Paper Mill and Beoley Mill) are so similar that they could have been held by the same master miller and leased out. Water probably came from the same network of springs. There seems to have been a sequence of old mills near here, probably going back to the 1600s.

Ipsley Mill, of all the old mills, rivers and ponds, is the most beautiful and the best known. A famous poet, Walter Savage Landor, lived in Ipsley House nearby. He wrote the following lines:

> In youth 'twas there I used to scare
> A whirring bird or scampering hare.
> And leave my book within a nook
> Where Alders lean above the brook
> To walk beyond the third millpond ...

The River Arrow at Ipsley is particularly attractive, with a pond bounded by trees and footpaths beside the river. At first the path follows the course of the former millpond beside great deep trenches. The river here is only a few metres away from Park Farm Industrial Estate but it feels more like Devon or Herefordshire.

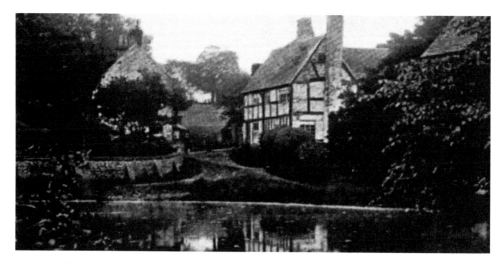

Ipsley Mill as it was in the poet's time.

Ipsley Mill today.

The Arrow Valley Lake

A popular destination for Redditch folk, the footpaths and cycle routes around the Arrow Valley Lake are well used. Yachts from the sailing club gracefully skim the surface of the water. Fishermen patiently sit on small platforms at the water's edge. Geese and ducks greedily compete for scraps thrown by visitors, and in the evening, as most people are leaving, shoals of large carp break the surface of the water with their broad backs as they search for leftovers.

Sunset over the lake.

The lake was the idea of the Redditch Development Corporation, partly as an amenity but also to solve Redditch's flooding problem. It covers 2 acres (8093.7 square meters) and is almost totally man-made. The spoil helped to raise the height of the Warwick Highway, which was under construction at the same time.

I Only Wanted a Shed

Many people remember Betty Passingham with affection. She and her husband lived in Batchley and they both became Labour councillors in the 1970s. The first newcomers were moving into the new town and there were many problems. Some could not afford the rents, there were no child-minding facilities, and financial pressures sometimes culminated in marital difficulties. Betty helped to found an honest money-lending system, created the Redditch Play Council, and founded Crossways Women's Refuge and The All Women's House. She also campaigned for the new hospital.

Strange to say, one of her most remarkable achievements is rarely mentioned. Each week Betty took a group of disadvantaged children to the Arrow Valley Lake for half a day of water sports. The school bus took them there then picked them up. Sometimes while they were at the lake, it began to rain and there was nowhere for them to shelter until the school bus arrived to pick them up. Betty asked the Redditch Borough Council if they could help with a basic shelter, perhaps a shed. The council representative said that he was sorry but they didn't have the finance. Then another councillor pricked up his ears at the word 'disadvantaged'. There were many grants available for disadvantaged children. The council managed to raise enough money to build the splendid Countryside Centre in the park. One wall is chiefly plate glass so that you can look at the view across the lake and watch the water sports in action while you drink your coffee. When Betty was alive she would often sit there, telling her friends, 'I only wanted a shed'.

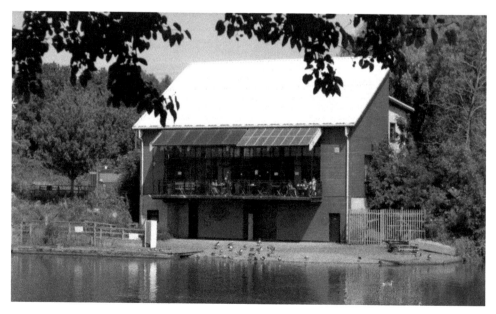

I only wanted a shed.

18. The Lost Farms of Redditch

Soon after the Redditch Development Corporation was established, they began compulsory purchasing land, including all the farms. For the farming families, watching the earth movers and heavy machinery dig up the fields and rip up the hedges, it must have been heartbreaking.

Pat Summers, of Walkwood Farm, when interviewed, said:

When Terry's sold the farm to the Redditch Development Corporation the family was very upset. My mother was the only person living there but two of my brothers came in each day to help run the farm. Then my mother fell in the night, she broke her hip and died a week later. One of my brothers moved back into the farmhouse with his wife and two children while the other brother continued to come in each day. They were able to run the farm for a little while – the Corporation kept taking certain fields off him until he was left with nothing. The farm house is still there at the top of Windmill Drive, it has changed very little but all the outbuildings have gone.

Winyates Craft Centre.

Some attempts were made by the Redditch Development Corporation to save buildings of architectural merit or historical interest. At Marlfield Farm, an old timber-framed barn was carefully taken down and its timbers reused as the central part of Bordesley Abbey and Forge Mill museum. Another old timber-framed barn at Winyates was re-erected as a community centre. The cowsheds and outbuildings were converted into a series of small units suitable for use as craft workshops. The community centre is currently used by a pre-school group, Women's Institute meeting, a karate class, a spiritual meeting and the 1st Winyates Rainbows. It is also available for hire.

Morton Stanley Park

This is one of Redditch's great successes. Every year it has festivals that attract several thousand. Its music festivals are so great that there are complaints about the noise 2 miles away. It covers a number of fields, and if you stand by a dividing hedge, you can get a different band in each ear. It's not the only event that attracts whole families from babies to grandads; the fair is there. The Morton Stanley festivals are no secret, but what is a secret is that the town very nearly lost the site.

The Morton Stanleys were a farming husband and wife. They lived in the house that is now Hill View Doctors' surgery. They owned 95 acres of beautiful Worcestershire

Morton Stanley Park is well known for its musical events.

countryside and had no heirs so they decided to leave it to the town, on condition that it was used for the benefit and enjoyment of the town's people. The Redditch Borough Council did use it for the benefit of the people in a way; they used it as a refuse tip. The bin lorries dumped the refuse there. Overseeing the transfer of land was Mr Phillips, the solicitor. He said that this wasn't appropriate to the terms of the will and if the rubbish was not removed the site would be sold. Fortunately, the Redditch Development Corporation arrived just in time and the rubbish was cleared. Now, if the Morton Stanleys are looking down upon us, I am sure they will have a big smile on their faces.

Ipsley Alders Marsh

There are two surprises about this nature reserve. First that it is there at all – so well is it hidden. Secondly, that it consists of 1.5-metre-deep sedge peat fed by springs rising through clay – a natural wetland in Redditch, not the East Anglian fens!

Ovoid in shape, the east side is hidden by residential housing estates and the west side is bounded by Alders Drive, a busy highway. Woodland and hedges shut out the view to traffic on the road.

It was designated a nature reserve in 1967 by Redditch Development Corporation and is now one of Worcestershire Wildlife Trusts nature reserves.

For most of the year the site is managed as a grazed marsh on which a few cattle live. Grazing prevents the growth of aggressive plants and grasses that would otherwise

A raised boardwalk crosses Ipsley Alders Marsh.

A pool beside Alders Drive, Ipsley Alders Marsh.

smother less vigorous plants. Over 170 varieties of typical wetland plants have been recorded at Ipsley Alders.

Two reed-enclosed pools are a magnet for dragonflies and damselflies as well as herons, kingfishers and frogs. Little Grebes are a delight to watch. Although they have less striking plumage than their larger relative, the Great Crested Grebe, they are charming little birds, particularly in the breeding season. Then parents and chicks can be seen together, the chicks learning how to dive for shrimps, dragonfly nymphs and, when a little older, sticklebacks.

From the moment they hatch the chicks are able to swim. At first sign of danger they scramble on to their parents' backs until the danger has passed. There is no knowing where a dabchick will reappear after it has dived – it may be many metres distant from its original position and be submerged for a surprising length of time.

In 2015 Ipsley Alders was voted one of the top five nature reserves in the country for the BBC *Countryfile Magazine* 'Reserve of the Year' awards.